WORLD FILM LOCATIONS SAN FRANCISCO

Edited by Scott Jordan Harris

First Published in the UK in 2013 by Intellect Books, The Mill, Parnall Road, Fishponds, Bristol, BS16 3JG, UK

First Published in the USA in 2013 by Intellect Books, The University of Chicago Press, 1427 E. 60th Street, Chicago, IL 60637, USA

Copyright ©2013 Intellect Ltd

Cover photo: *Dirty Harry* (1971)
© Warner Bros / The Kobal Collection

Copy Editor: Emma Rhys

A Catalogue record for this book is available from the British Library

World Film Locations Series
ISSN: 2045-9009
eISSN: 2045-9017

World Film Locations San Francisco
ISBN: 978-1-78320-028-3
ePDF ISBN: 978-1-78320-113-6
ePub ISBN: 978-1-78320-114-3

Printed and bound by
Bell & Bain Limited, Glasgow

WORLD FILM LOCATIONS SAN FRANCISCO

EDITOR
Scott Jordan Harris

SERIES EDITOR & DESIGN
Gabriel Solomons

CONTRIBUTORS
Samira Ahmed
Nicola Balkind
David Owain Bates
Robert Beames
Olivia Collette
Brian Darr
Jez Conolly
Peter Hoskin
Simon Kinnear
Jason LeRoy
Michael Mirasol
Neil Mitchell
Omar Moore
Craig Phillips
Elisabeth Rappe
Mel Valentin

LOCATION PHOTOGRAPHY
Alex Solomons
(unless otherwise credited)

LOCATION MAPS
Joel Keightley

PUBLISHED BY
Intellect
The Mill, Parnall Road,
Fishponds, Bristol, BS16 3JG, UK
T: +44 (0) 117 9589910
F: +44 (0) 117 9589911
E: *info@intellectbooks.com*

Bookends: *Vertigo* (Kobal)
This page: *Mrs Doubtfire* (Kobal)
Overleaf: *Bullitt* (Kobal)

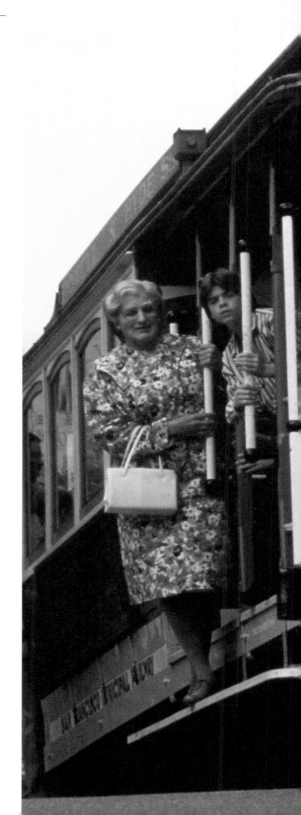

CONTENTS

Maps/Scenes

10 **Scenes 1-8**
1898 - 1947

30 **Scenes 9-16**
1951 - 1963

50 **Scenes 17-24**
1967 - 1974

70 **Scenes 25-32**
1974 - 1984

90 **Scenes 33-39**
1986 - 1995

108 **Scenes 40-46**
1996 - 2011

Essays

6 **San Francisco:**
City of the Imagination
Omar Moore

8 **The Golden Gate Bridge:**
Gateway, Escape Route
and Battleground
Neil Mitchell

28 **City of Shadows:**
A Brief History of Film
Noir in San Francisco
Brian Darr

48 **Alfred Hitchcock Presents**
San Francisco: The Master
and the City by the Bay
Craig Phillips

68 **Faster Than a Speeding**
Bullitt: San Franciscan
Cinema's Famous Car Chases
Mel Valentin

88 **Callahan's City:**
Dirty Harry and the Mean
Streets of San Francisco
Elisabeth Rappe

106 **Midnight Mission:**
Queer Culture and Midnight
Movies in San Francisco
Jason LeRoy

Backpages
124 *Resources*
125 *Contributor Bios*
128 *Filmography*

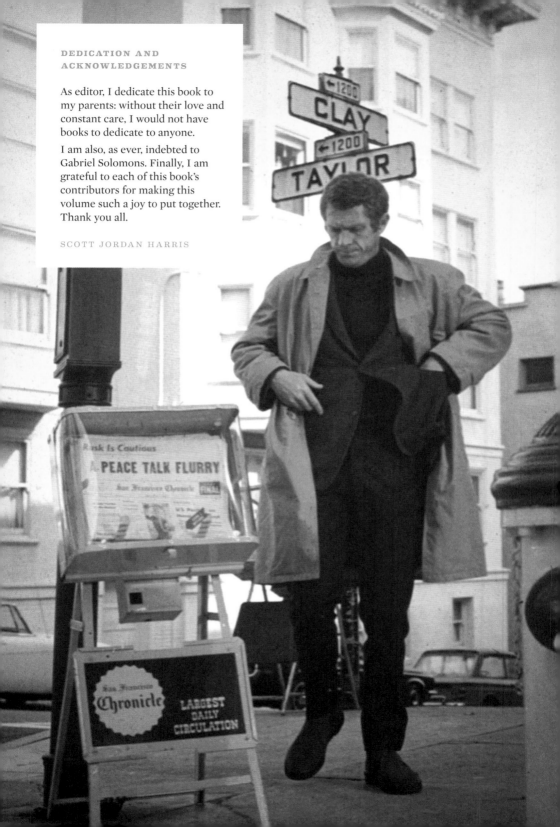

DEDICATION AND ACKNOWLEDGEMENTS

As editor, I dedicate this book to my parents: without their love and constant care, I would not have books to dedicate to anyone.

I am also, as ever, indebted to Gabriel Solomons. Finally, I am grateful to each of this book's contributors for making this volume such a joy to put together. Thank you all.

SCOTT JORDAN HARRIS

INTRODUCTION

World Film Locations San Francisco

I AM PARTICULARLY PROUD to have edited this volume of the *World Film Locations* series. San Francisco is an extraordinary city that has been celebrated, criticized and studied in many extraordinary films. It is a city both fragile and robust: able, because of its location, to be devastated by the horrors of the 1906 earthquake but also able, because of the innate indomitability of its population, to rebuild itself afterwards. Its beauty, both natural and man-made, has provided film-makers with an unmistakable backdrop since the 1890s.

What fascinates me most about San Francisco are the contrasts it presents, both in life and on-screen. It is a city of rebellion and liberty that launched the summer of love and houses The Castro, America's largest and most renowned gay district. But it was also home to the brutal tyranny of Alcatraz and to the *Dirty Harry* films (Don Siegel, et al., 1971–88), which the immortal movie critic Pauline Kael famously characterized as 'fascist'. Many of these contrasts are reflected in the films featured in this book.

Thousands of films have been made in San Francisco and we can, of course, only include a fraction of them here. This volume, like all those in the World Film Locations series, does not aim to be exhaustive or encyclopaedic. It merely aims to present a cross-section of the films that have been made in, and inspired by, the city it showcases.

Alongside 46 short pieces on 46 specific scenes from 46 San Franciscan films, this book includes several essays on topics that dominate the history of film-making in the city, from depictions of the Golden Gate Bridge, to the movies Alfred Hitchcock made in San Francisco, to the car chases that seem to be mandatory features of any thriller shot there.

Many kinds of films, made across more than 100 years, are featured. There are documentaries and shorts; arthouse classics and popular musicals; masterpieces of film noir and twenty-first century blockbusters. There are those famous films we simply could not omit, such as *The Maltese Falcon* (John Huston, 1941), *Vertigo* (Alfred Hitchcock, 1958) and *Bullitt* (Peter Yates 1968), and some less obvious films that could easily have been omitted but whose inclusion adds extra depth and detail to the book and the portrait it paints of San Francisco. These are films such as *San Francisco: Aftermath of an Earthquake* (various, unknown, 1906), *Time After Time* (Nicholas Meyer, 1979) and *The Wild Parrots of Telegraph Hill* (Judy Irving, 2005).

All the films in this book are united by their setting. And the scenes from them to which we pay special attention are united by the special attention they pay to particularly noteworthy San Franciscan locations. Some of these, such as the Golden Gate Bridge, are likely to exist forever. Others, such as the Playland amusement park, can now only be visited on film.

So, if you're going to San Francisco, whether in person, at the cinema or just in your imagination, we hope this book will inform and entertain you on your trip. ✠

Scott Jordan Harris, Editor

SAN FRANCISCO

City of the Imagination

Text by
OMAR
MOORE

SAN FRANCISCO. MYSTERIOUS. Beautiful. Heavenly. Fascinating. In the history of the movies San Francisco is each of these things. The City by the Bay that Tony Bennett sings so lovingly of has a special alchemy, and its fog is like a brew that entrances visitors and residents alike. There's something unmistakable that San Francisco does to your senses. When you first set eyes on San Francisco, your heart is filled with a sense of heaven. The sight of this city is breathtaking. Victorian houses. Twin Peaks. The Presidio. Alcatraz. Cable cars. The deep blue sky on sunny October days, and the houses and the water that contrast and sparkle so strikingly against it.

Film-makers are entranced by San Francisco. It is a picturesque city, a breathtaking city. There's a European feel to my city that makes it unique. Forty-three 'official' hills. Forty-nine square miles. The Golden Gate Bridge gives the city that I love

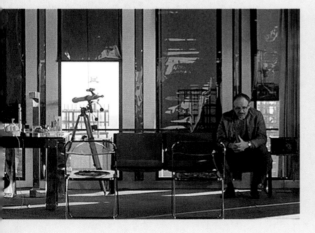

gravitas. The marvellous wonder of that deep red bridge gives context to the mystery that surrounds it. The bridge offers a majestic platform from which to absorb the city – my city, your city, our city. San Francisco belongs to everyone, whether you live here or not.

I enjoy being a tourist in my city. San Francisco is completely distinct from any other American city, and Alfred Hitchcock and countless other film-makers have made full use of it as a character. In *Vertigo* (Alfred Hitchcock, 1958) the city was the depth and perception of vision and landscape. Hitchcock used San Francisco as a blinding beauty, analogizing it through Novak's mystical, otherworldly character in such a way as to be deeply overwhelming to Jimmy Stewart's character. This beauty and intoxicating vision is the very heart of San Francisco itself.

If films such as *Vertigo* showcase intimacy with and curiosity about San Francisco, then movies such as *San Francisco* (W. S. Van Dyke, 1936), with Clark Gable and Spencer Tracy, and *Guess Who's Coming To Dinner* (Stanley Kramer, 1967) metaphorically represent the open arms of the city. It's a welcoming beacon for differing attitudes and individuals. The mantra 'make love, not war' fuels both films in a way, though not without farce or drama.

In *San Francisco*, Gable rivals Tracy for the affections of Jeanette MacDonald, while Sidney Poitier had to win over Tracy and Katharine Hepburn in *Guess Who's Coming To Dinner* to marry their daughter (Katharine Houghton). The colour of San Francisco as a golden California city is vibrant in both films, yet one was released

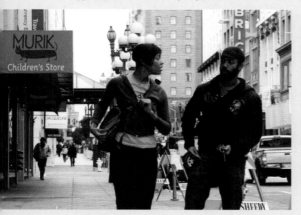

Above © 2009 Strike Anywhere
Opposite © 1974 American Zoetrope

who were never found, adds to San Francisco's layers of mystery. *The Rock* is a boisterous playground of aggression and testosterone, a muscular rejoinder to the timeless peace and love offerings of the Haight-Ashbury district, less than five miles away.

Conversely, *The Conversation* (Francis Ford Coppola, 1974), a film I would call a horror classic, unfolds in the benign setting of Union Square, the shopping centre of San Francisco. The opening overhead shot of Union Square feels like a hawk's-eye view, and the film's quiet terror becomes a devastating crescendo. Francis Ford Coppola's drama generates fear, tension and paranoia, and those emotions are also felt in David Fincher's San Francisco thrillers *Zodiac* (2007) and *The Game* (1997), both of which capture a frenzy and wildness signifying an undeniable element of San Francisco.

Zodiac captures the notorious late 1960s/early 1970s serial killings that terrified San Francisco, yet much of *Zodiac* was shot in Los Angeles, while *The Game* was shot almost entirely in San Francisco. Both films share a macabre horror that punctures the city's beautiful facade yet simultaneously enhances it because of the intrigue and fascination swirling around it. In a way, the danger flaunted in both films is ambiguous, even attractive – a cocktail of obsession and addiction erupting in an alternately passive and activist city.

A film about outsiders trying to fit in, Barry Jenkins's *Medicine For Melancholy* (2009) is about the dwindling percentage of blacks living in an increasingly expensive San Francisco today. *Medicine*, shot in indelible black and white and on the fly in San Francisco some forty years after many blacks were forced out of the city's Fillmore District to move to more affordable places in the East Bay, is an effective, penetrating exploration of one man's love-hate relationship with San Francisco. Sometimes Wyatt Cenac's character feels he belongs, but more often he feels like a stranger alienated from an uncaring city. Far bleaker, however, is *The Bridge*, Eric Steel's disturbing 2006 documentary about the Golden Gate Bridge as a magnet for suicide for the depressed and disillusioned.

San Francisco is rich with movie tradition. The city I love is such a multifaceted city, so distinct, so unforgettable. San Francisco is an addiction. San Francisco is magnetic. You can't help but love San Francisco when you are there, and yearn for it like a lovesick devotee when you are not. ✢

in 1936 and the other in 1967. Ironically, *San Francisco* was shot in Hollywood, with just a few scenes actually set in the city itself.

For all the sunshine and idealism of films like *Guess Who's Coming To Dinner* – a film released at a very volatile time in American history and a turning point in San Francisco's history, politics and shifting demographics – the city, for all its seeming compassion and liberalism, can often be cold, indifferent and unfeeling. The *Dirty Harry* films (Don Siegel, et al., 1971–88) of the 1970s and 1980s represent the murky heart of San Francisco: the vigilantism factor that is unspoken – a direct buttress against what some decry as a lack of aggression towards fighting crime on the part of law enforcement agencies in the city.

San Francisco is a moody city, one with unpredictable rhythms. Sometimes the city's energy is high. Other times it is low and mostly laid back. While the fog in San Francisco is romantic and enchanting, the city's cool climate is an element occasionally made brutal on film, at least in an analogous way. *Escape From Alcatraz* (Don Siegel, 1979) and *The Rock* (Michael Bay, 1996), both about Alcatraz, a seemingly inescapable force, symbolically represent a finite aspect of a San Francisco whose wonders and bounties cannot be grasped because of the sheer natural beauty the city possesses.

Escape From Alcatraz, based on the true story of Alcatraz jail escapees

San Francisco is a moody city, one with unpredictable rhythms. Sometimes the city's energy is high. Other times it is low and mostly laid back.

THE GOLDEN GATE BRIDGE

Text by
NEIL
MITCHELL

Gateway, Escape Route and Battleground

SAN FRANCISCO'S Golden Gate Bridge can stake a strong claim to being the most famous structure of its kind in the world. Painted in international orange, standing 746 feet tall and stretching 8,981 feet long, the suspension bridge that crosses the Golden Gate Strait between the city and the County of Marin was already a regular feature on the big screen by the time it opened in May of 1937. From the 1926 silent crime drama *Black Paradise* (Roy William Neill) via the arthouse stylings of Richard Lester's *Petulia* (1968) and the family fun of *Herbie Rides Again* (Robert Stevenson, 1974), to more recent offerings such as the Mike Myers comedy *So I Married an Axe Murderer* (Thomas Schlamme, 1993) and the 2008 biopic *Milk* (Gus Van Sant), the bridge has appeared in well over 100 movies, television shows and documentaries.

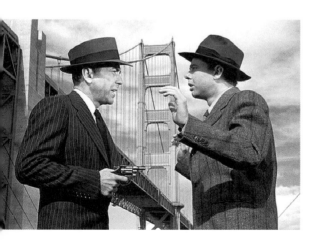

An awe-inspiring feat of architecture and engineering, the city's most prominent landmark prompted renowned travel writer Mary Moore Mason to eulogize that 'the Golden Gate Bridge's daily strip tease from enveloping stoles of mist to full frontal glory is still the most provocative show in town' (*Essentially American*, July/August 2000). When a movie is set in the city, it's a given that the bridge will make an appearance, whether in a brief establishing shot or a crucial scene.

That most stylized and atmospheric sub-genre of crime movies – film noir – made particularly fertile use of the bridge within narratives revolving around psychotic killers, double crossings, vengeful obsession and doomed lovers. In Anthony Mann's *Raw Deal* (1948), the bridge is seen from a ship's cabin as escaped prisoner Joe Sullivan (Dennis O'Keefe) has to decide whether to flee San Francisco with the love-struck Pat (Claire Trevor) or be sucked back into the city's underworld. The bridge here becomes a symbolic Rubicon, with one way pointing to salvation and the other to damnation. Being a film noir, you know which path he'll take: the fog-shrouded bridge cruelly offering the chance of freedom while inexorably luring Joe to his fate.

The bridge plays a dual role as gateway and gravestone in Delmer Daves's *Dark Passage* (1947), allowing Humphrey Bogart's wrongfully convicted Vincent Parry entry into the city and later acting as a temporary headstone for his would-be blackmailer, who lies dead under its shadow. The city claims another life, one lost to its pleasures and spat out as a victim of his own greed, with the bridge an impassive onlooker.

in major urban environments.

The Golden Gate's status as a marker of civilization has inevitably led to it being frequently utilized by directors in movies in which major disasters occur, or the threat of them looms. Mutated sea creatures in *It Came From Beneath the Sea* (Robert Gordon, 1955) and *Mega-Shark vs Giant Octopus* (Jack Perez, 2009); natural or man-made disasters in *Superman* (Richard Donner, 1978), the TV movie *Earthquake 10.5* (John Lafia, 2004) and *The Core* (Jon Amiel, 2003); and criminal megalomaniacs in *A View to a Kill* (John Glen, 1985) and *X-Men: The Last Stand* (Brett Ratner, 2006) have all attacked, besieged, destroyed and fought on or above the Golden Gate.

It has been ripped apart, melted and uprooted, its gigantic frame reduced to rubble and its physical space invaded by those who would do us harm. If the bridge is under threat, ergo mankind is under threat. When the deserted structure is glimpsed in Stanley Kramer's *On the Beach* (1959), and Denzel Washington's titular figure wanders its eerily quiet, ruined environs in *The Book of Eli* (The Hughes Brothers, 2010), one is reminded that empires fall and nothing lasts forever.

Though the bridge itself remains largely undamaged in Rupert Wyatt's *Rise of the Planet of the Apes* (2011), its physical space and symbolic status has never been more thrillingly utilized. The climactic twenty-minute sequence on the Golden Gate Bridge, where the escaped, genetically enhanced apes wage war with the San Francisco Police Department's officers, is steeped in narrative resonance. The bridge becomes a battleground, a site where the future of mankind is put on the line. The physical make-up of the Golden Gate is used as an easily traversed climbing frame by the newly emancipated primates, with the humans left trapped and exposed on a creation of their own making. As in *Raw Deal*, the bridge again becomes a Rubicon: one way re-establishes the natural order and the other offers a Darwinian nightmare of mankind toppled from its position at the top of the food chain.

The Golden Gate Bridge may be a wondrous sight to behold in reality; the pride of a city and a testament to man's progress and achievement, but on the big screen it is far less fixed in definition. Once it has been used to establish the San Francisco location, reality gives way to fantasy and the bridge takes on many varied lives. ✤

Similarly, in Don Siegel's *The Lineup* (1958), the Golden Gate teasingly offers itself as an escape route before a police blockade ends with unhinged killer Dancer (Eli Wallach) and his criminal colleagues meeting their maker under its emotionless gaze.

Alfred Hitchcock fully exploited the gigantic structure's metaphorical qualities – specifically as a symbol of the overwhelming, alienating and isolating nature of a modern metropolis – during *Vertigo* (1958), in a scene later spoofed in Mel Brooks's *High Anxiety* (1977). Troubled, enigmatic Madeleine (Kim Novak) throws herself into San Francisco Bay from Fort Point, only to be rescued by Scottie (James Stewart), the increasingly obsessed ex-cop hired to trail her. Looming over them is the bridge, their private lives dwarfed in juxtaposition with the gigantic public structure. *Vertigo* may be fiction, but the Golden Gate's notorious reputation as a suicide hotspot was thrown into clarity by Eric Steel's profoundly unsettling 2006 documentary, *The Bridge*. Steel shot the Golden Gate during daylight hours from two different positions throughout 2004, capturing the tragic deaths of nearly two dozen people on camera. Interviews with family members, friends and witnesses starkly confronts the mental and emotional well-being of residents

The Golden Gate's status as a marker of civilization has inevitably led to it being frequently utilized by directors in movies in which major disasters occur, or the threat of them looms.

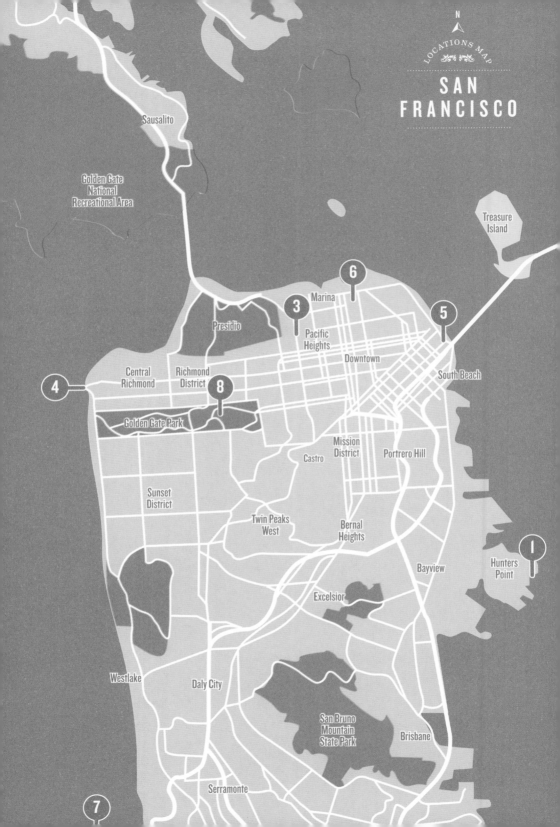

3

SAN FRANCISCO LOCATIONS

SCENES 1-8

1.
LAUNCH OF JAPANESE
MAN-OF-WAR 'CHITOSA' (1898)
The Union Iron Works shipyard,
now part of the San Francisco Dry Dock
page 12

2.
SAN FRANCISCO:
AFTERMATH OF AN EARTHQUAKE (1906)
The City of San Francisco
page 14

3.
THE NAVIGATOR (1924)
Divisadero and Broadway Streets,
Pacific Heights
page 16

4.
GREED (1924)
The Cliff House Restaurant,
1090 Point Lobos
page 18

5.
THE MALTESE FALCON (1941)
The San Francisco – Oakland Bay Bridge,
San Francisco Bay and (a Hollywood
recreation of) 111 Sutter Street
page 20

6.
DARK PASSAGE (1947)
The Penthouse apartment, 1090
Chestnut Street; 1201 Greenwich Street;
and Hyde Street
page 22

7.
MY FAVORITE BRUNETTE (1947)
The Crocker-Irwin Mansion,
Pebble Beach, San Francisco Bay Area
page 24

8.
THE LADY FROM SHANGHAI (1947)
Steinhart Aquarium, Golden Gate Park
page 26

maps are only to be taken as approximates

LAUNCH OF JAPANESE MAN-OF-WAR 'CHITOSA' (1898)

LOCATION *The Union Iron Works shipyard, now part of the San Francisco Dry Dock*

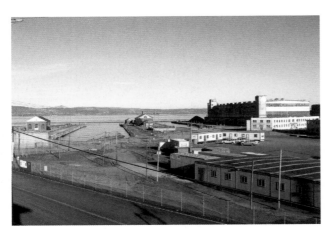

THOMAS EDISON'S IMPORTANCE as a film-maker is often overlooked, but the documentaries he shot at the end of the nineteenth century and the beginning of the twentieth not only recorded sights – like himself working in his laboratory or the antics of a trick cyclist – that would otherwise have gone un-filmed, but also helped show the world that such sights could be filmed at all. Shot at the Union Iron Works shipyard on Saturday 22 January 1898, Edison's *Launch of Japanese Man-of-War 'Chitosa'* is one of the earliest San Francisco films. It shows the slow slide into San Francisco Bay made by the Japanese naval cruiser usually called Chitose (the spelling used in the title is an uncommon variation). The ship, which was over 400 feet long and weighed more than 4,600 tons, had been built at the shipyard, which at the time was the biggest on the Pacific Coast. The yard still operates today, as part of the San Francisco Dry Dock. Edison's footage is beyond grainy, and now seems positively prehistoric, but it still manages to capture the atmosphere of the occasion. Dock workers can be seen staring eagerly and men manoeuvre their rowboats to get a better view. In a hilarious moment, two boys, apparently overcome with excitement, dive into the water fully dressed. This shortest of shorts must have been one of the first movies made with an international audience in mind: it was sent to Japan, where it apparently played to great acclaim. ➥*Scott Jordan Harris*

Directed by Thomas Edison
Scene description: A special day at the Union Iron Works shipyard
Timecode for scene: 0:00:00 – 0:00:55

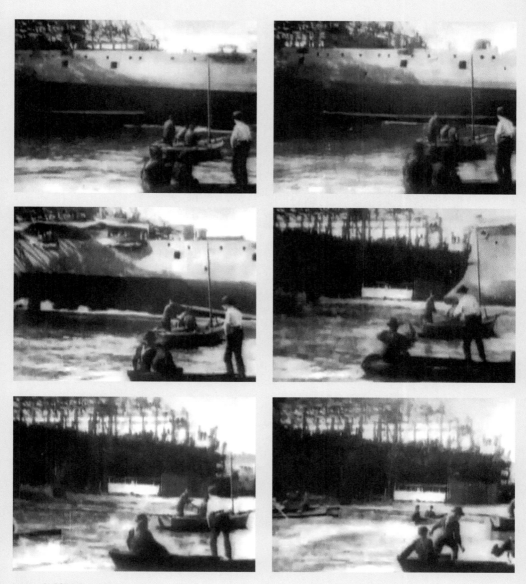

SAN FRANCISCO: AFTERMATH OF AN EARTHQUAKE (1906)

The City of San Francisco

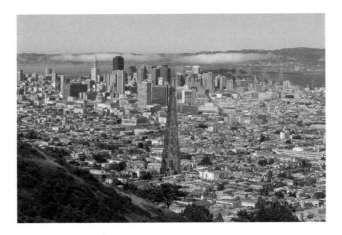

ONE OF THE MOST EFFECTIVE FILMS ever shot in San Francisco is only a minute and a half long. What's more, it is silent, black and white, and the name of its director seems to have been lost to history. What will never be lost to history, however, are the images the film preserves: images of the destruction caused by the 1906 San Francisco earthquake, one of the worst natural disasters in American history. *San Francisco: Aftermath of an Earthquake* is documentary-making in its purest form. Soon after the earthquake, and apparently long before it was safe to do so, the film-makers took out their cameras and simply recorded the devastation around them. We see the infamous fires that followed the quake sending up eruptions of smoke and dust. We see a family fleeing in a horse cart. We see formerly straight streetcar tracks suddenly winding like a meandering river. And we see the fallen remains of what used to be buildings. What is most remarkable is how little the modern conventions of sound, colour, high-definition pictures, interviews and narration would add to the film. Though it is, in cinematic terms, an ancient artefact, *Aftermath of an Earthquake* is still shocking and still horrific. It will always be invaluable. Pleasingly, it ends with a sense of hope when the camera lingers on a sign reaching out of the rubble and declaring: 'A little disfigured but still in business. Men Wanted.' Even as the fires still burned, San Francisco's recovery had already begun. **◆Scott Jordan Harris**

Photo © Vincent Bloch (wikimedia commons) / Market Street from Twin Peaks

Directed by Various, unknown
Scene description: Surveying the damage
Timecode for scene: 0:00:00 – 0:01:23

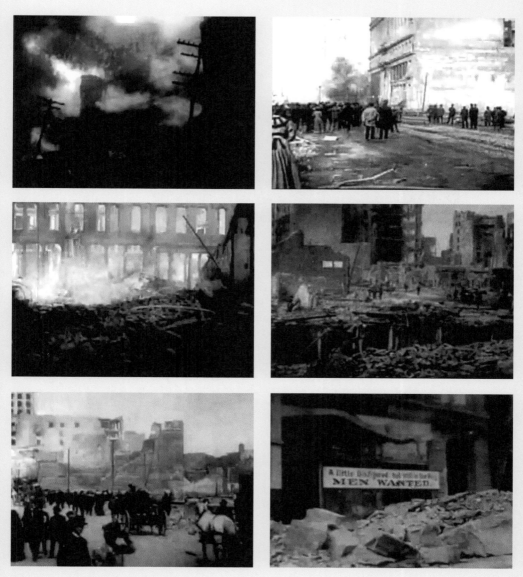

Images © 1906 America Mutoscope & Biograph

THE NAVIGATOR (1924)

LOCATION *Divisadero and Broadway Streets, Pacific Heights*

BUSTER KEATON – whom Orson Welles called 'the greatest of all the clowns in the history of cinema' – stars in *The Navigator*, a silent comedy he co-directed. With his signature 'stone face', Keaton plays Rollo Treadway, heir to a large fortune and, as written in the film's intertitles, 'living proof that every family tree must have its sap'. Rollo's privileged background does not, however, insulate him from rejection: after proposing to girl-next-door Betsy (Kathryn McGuire), who refuses him, he retreats to his mansion, which faces Betsy's. Rather than drive the short distance across Divisadero Street between the two estates, Rollo deadpans that a 'long walk' would do him good – and proceeds to reach his home on foot in a few seconds, his chauffeur and footman closely following by car. Filmed within Pacific Heights' 'Gold Coast', this early scene tells viewers that Betsy and Rollo are both enormously wealthy. As the pampered Rollo is well aware, he will not be able to wake up on time to catch a 10 a.m. boat the next morning for his solo honeymoon in Hawaii. Therefore, he decides to board that very evening. After several mishaps, Betsy and Rollo are stranded on the ship Navigator as it drifts across the Pacific Ocean. Without any shipmates, these two children of privilege are forced to perform tasks from domestic chores to deep sea diving in order to survive their misadventures at sea. While Keaton's *The General* (1926) is widely considered his best film, *The Navigator* was his most profitable.
~Marcelline Block

Photo © Gabriel Solomons

Directed by Buster Keaton and Donald Crisp
Scene description: 'I think a long walk would do me good.'
Timecode for scene: 0:05:05 – 0:06:22

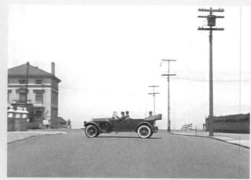

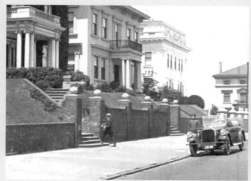

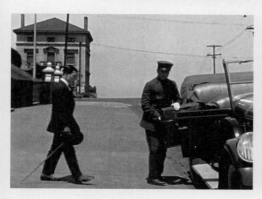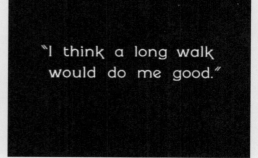

"I think a long walk would do me good."

GREED (1924)

The Cliff House Restaurant, 1090 Point Lobos

THE SETTING FOR ONE OF the pivotal scenes in Erich Von Stroheim's *Greed* is outwardly charming. Two friends, John McTeague (Gibson Gowland) and Marcus Schouler (Jean Hersholt), sit at a small, round table in the corner of the Cliff House restaurant. Through the window behind them, people can be seen gliding along the boardwalk, the sunlit sea farther beyond. As shown in cutaway shots, a pianola plays jauntily in the background. Everything is the image of 1920s seaside gaiety. But, as we know, image isn't everything – and the charm soon starts to evaporate. McTeague, after all, has something to confess: he has fallen for Schouler's cousin, and own love interest, Trina Sieppe (ZaSu Pitts). And the nature of his confession is rather creepy. 'Why I was so close to her and smelt her hair and felt her breath,' he says of the girl who was a patient in his dentist's chair. 'Oh, you don't know.' At which point, Schouler stands up and stares out of the window, seeing through the boardwalk to the bare sea and rocks beyond. These, incidentally, are rocks that have claimed numerous ships over the years. From here, nothing can return the scene to sunny normality, not even Schouler's eventual concession to McTeague – that he will stand aside and allow his friend to court Ms Sieppe. This is one of the few instances of decency in the entire film, yet, as Schouler puts it, the two men are now 'Friends for life … or death!' Let's just say that this relationship might end badly. **➻ Peter Hoskin**

Directed by Erich Von Stroheim
Scene description: McTeague confesses his love for Trina
Timecode for scene: 0:46:25 – 0:50:53 (in the 239-minute reconstructed cut)

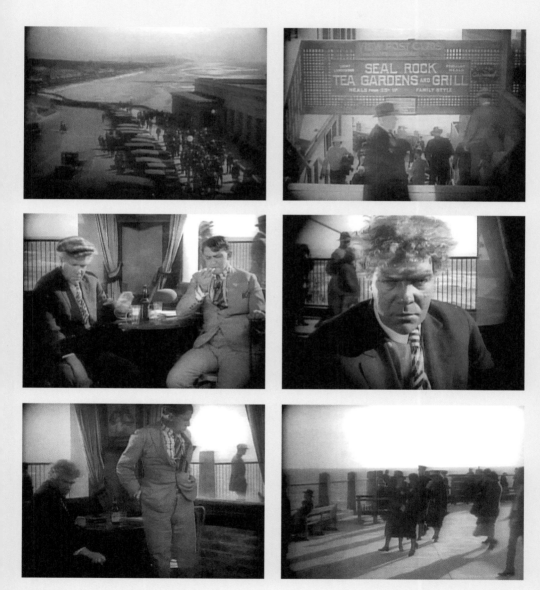

THE MALTESE FALCON (1941)

LOCATION

*The San Francisco – Oakland Bay Bridge,
and (a Hollywood recreation of) 111 Sutter Street*

A FILM NOIR MASTERPIECE, John Huston's adaptation of Dashiel
Hammet's equally acclaimed novel, *The Maltese Falcon* (1930), is an enduring
classic. It gives us the defining figure of the private-eye archetype, Humphrey
Bogart's Sam Spade, and captures the spirit of 1940s America. Equally,
the San Francisco – Oakland Bay Bridge, now a centrepiece of any San
Franciscan establishing montage, has its defining moment as an iconic
location here. After the dramatic scrolling text opening, which sets up
the story of the eponymous statue, the film really begins as it fades up on
an establishing shot of San Francisco. The Gold Rush City's brand new
Bay Bridge takes the foreground. And rightly so, as it opened for traffic in
November 1936, six months before its sister, the Golden Gate Bridge, which
we see advertised on the Ferry Building. (This is probably stock footage, as
the film was shot in the summer of 1940.) The perspective shifts and, looking
out towards the city proper, we see that many of the city's iconic skyscrapers
are not yet built. The camera descends and we are introduced to an office
announcing 'SPADE AND ARCHER', where Sam Spade is working as the
Bay Bridge gleams through a large window. The office interior was shot
in LA but the location is estimated to be 111 Sutter Street at the corner of
Montgomery in the heart of the Financial District – not far from neo-noir's
favourite location: Chinatown. Although *The Maltese Falcon* was made in
Hollywood, we're never allowed to forget it is set in San Francisco.
∙➤ Nicola Balkind

Directed by John Huston
Scene description: Establishing San Francisco as our setting
Timecode for scene: 0:01:20 – 0:02:07

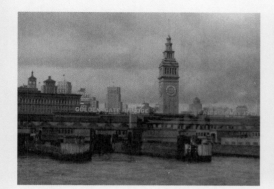 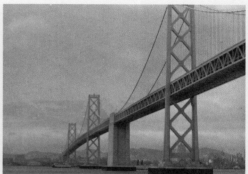

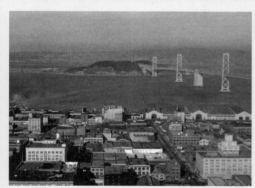 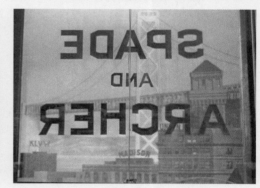

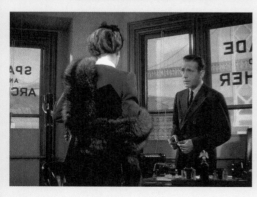 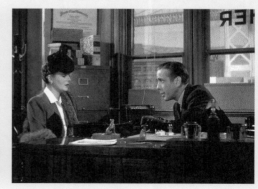

Images © 1941 Warner Bros. Pictures

DARK PASSAGE (1947)

LOCATION *The Penthouse apartment, 1090 Chestnut Street; 1201 Greenwich Street; and Hyde Street*

SCREWED-UP, that's the only way to describe the meeting between Humphrey Bogart and Agnes Moorehead towards the end of *Dark Passage*. They play Vincent Parry and Madge Rapf, a pair who ... well, let's just say that the latter may once have killed the former's wife in a fit of mad love, and then pinned the crime on Parry himself. This is the final confrontation between the two and as you'd expect from any film of this sort, there's a twist: Rapf doesn't recognize her nemesis at first because of plastic surgery Parry had done to conceal his identity. Murderous obsessive meets unrecognizable man. As I say, it's a bit screwed-up. But the scene is also screwed-up in another sense. From the moment Parry appears at Rapf's door, pretending to be a potential lover, the tension is forced constantly upwards, as if by a screwdriver. It's perturbing enough to begin with, as Rapf allows this stranger into her apartment, the horizontal stripes of her dress clashing against the vertical stripes of his suit. But it soon gets worse as she learns the truth about the man behind the face. The mania that she has been holding back behind her own mask of propriety slips out. And then – is it by accident or by design? – she falls through the window, falls floor after floor to the street below. How apt that Parry then leaves the scene by a winding fire escape from the building's roof. This is another screw, but it feels like one that's being eased out in the opposite direction. It's a whirl that takes him away from San Francisco, away from all this madness. ↝**Peter Hoskin**

Photos © Gabriel Solomons

Directed by Delmer Daves
Scene description: A murderess confronted
Timecode for scene: 1:25:26 – 1:34:51

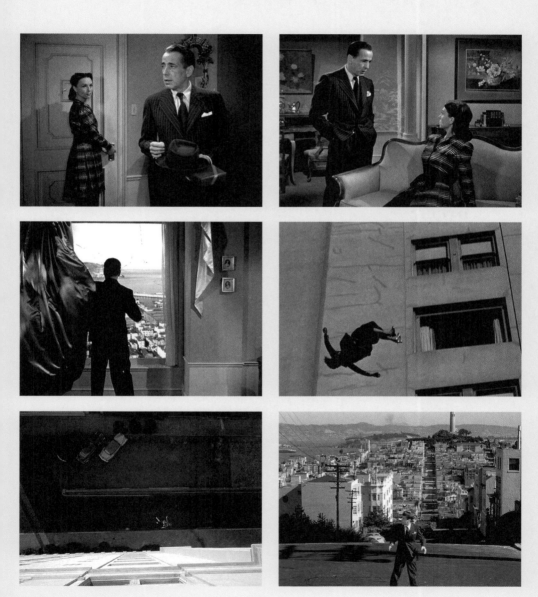

Images © 1947 Warner Bros. Pictures

MY FAVORITE BRUNETTE (1947)

The Crocker-Irwin Mansion, Pebble Beach, San Francisco Bay Area

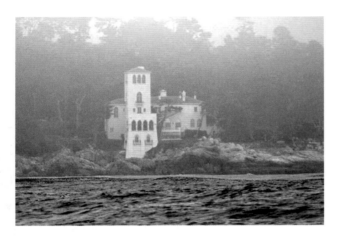

MY FAVORITE BRUNETTE spoofs detective films, with Bob Hope starring as photographer Ronnie Jackson, who specializes in baby pictures but aspires to be a 'hardboiled detective like Humphrey Bogart or Dick Powell or even Alan Ladd'. Mistaken for the private investigator next door – none other than Ladd himself – Ronnie is hired by the titular brunette, Carlotta Montay (Dorothy Lamour), to rescue her kidnapped uncle. At her request, Ronnie follows Carlotta from downtown San Francisco to a magnificent Pebble Beach home. This sequence was filmed at the neo-Byzantine Crocker-Irwin Mansion, named for the family of railroad magnate Charles Crocker. Sugar heiress Helene Irwin, the ex-wife of Crocker's grandson, bought the land in 1923 (before their divorce), hiring architect George Washington Smith to build one of the grandest structures of its era and region, with materials such as stone from Mount Vesuvius and imported marble, and gold-trimmed antique fixtures. Upon Ronnie's arrival at the mansion – the imposing exterior of which boasts archways, columns and an intricately carved doorway – he compares it to Wuthering Heights, calling it 'the kind of house that looks like you can hunt quail in the hallways. I didn't know it then, but I was going to be the quail'. Kismet (played by a characteristically sinister Peter Lorre), whom Ronnie ironically nicknames 'Cuddles', answers the door. Thus begins Ronnie's ordeal, which includes being framed for murder. Yet he maintains his sense of humour throughout, never missing an occasion to joke – this is, after all, a Bob Hope film. ↝*Marcelline Block*

Directed by Elliott Nugent
Scene description: Ronnie arrives at 'Wuthering Heights'
Timecode for scene: 0:14:40 – 0:15:31

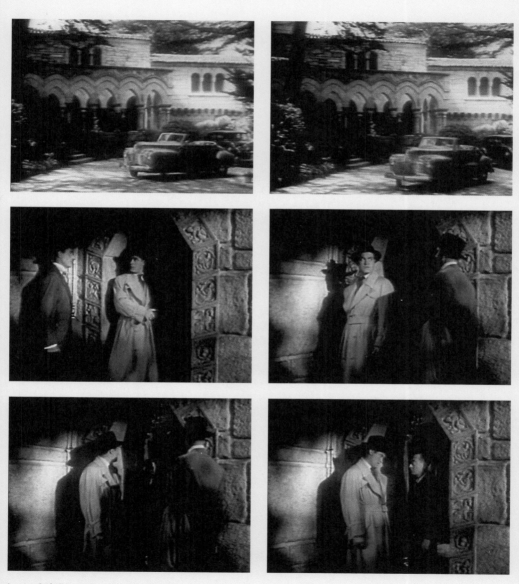

THE LADY FROM SHANGHAI (1947)

LOCATION *Steinhart Aquarium, off Hagiwara Tea Garden Drive and Martin Luther King Jr Drive, Golden Gate Park*

SAN FRANCISCO: surely the perfect place for lovers to meet? Yet Orson Welles's noir thriller subverts any sense of amour by choosing the city's Steinhart Aquarium as the location for this furtive hook-up between adulterous Michael O'Hara (Welles) and Elsa Bannister (the star's real-life wife, Rita Hayworth). The scene was shot when the actors were estranged and soon to be divorced, and that tension shows up in Welles's vivid deconstruction of a romantic rendezvous into something dark and dangerous. Michael and Elsa are laughed at by schoolchildren and surrounded by predatory sea creatures, the latter magnified in grotesquely exaggerated compositions that literally overshadow the actors. It's a sequence full of irony and symbolism. Michael and Elsa fell in love at sea, while the prominence of sharks in the imagery reflects a story told earlier in which O'Hara compares the Bannisters to sharks he once saw chewing each other – and themselves – to death. Of course, Welles would neither confirm nor deny any deeper meaning behind the location. When asked years later by biographer Peter Bogdanovich why he selected the aquarium, the writer/director/star replied simply, 'Why not?' Welles could easily have pointed to the Steinhart's reputation as one of San Francisco's major tourist attractions or to Hollywood's abiding fascination with the location: Don Siegel also filmed part of 1958's *The Lineup* there. Today, the Steinhart looks nothing like the startling, surreal place where Welles and Hayworth hatched their plans, having been rebuilt after suffering serious structural damage during the 1989 earthquake. ➛*Simon Kinnear*

Directed by Orson Welles
Scene description: *A secret rendezvous between Orson Welles and Rita Hayworth*
Timecode for scene: *0:43:01 – 0:46:25*

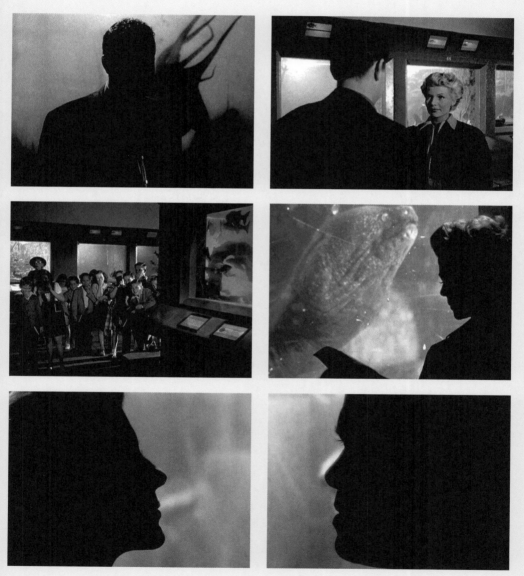

CITY OF SHADOWS

A Brief History of Film Noir in San Francisco

Text by
BRIAN
DARR

MURDER AND MOVING PICTURES have been linked to San Francisco since pre-cinematic days. Eadweard Muybridge was slowly discovering how to photograph a horse's motion when, in October 1874, he interrupted this work to kill his wife's lover, Harry Larkyns, in cold blood. Acquitted by jury on the grounds of 'justifiable homicide', he soon resumed his project, which culminated in *Sally Gardner at a Gallop*, a groundbreaking 1878 multi-camera study filmed at a racetrack just south of his San Francisco home. The result meant international fame for Muybridge and a new form of entertainment for the world: the movie.

Fifty years later, a San Francisco ex-detective named Dashiell Hammett created the hard-boiled private investigator Sam Spade. His exploits were published in the novel *The Maltese Falcon* (1930), which was turned into three feature films. The wild success of John Huston's 1941 version launched

a fifteen-year cycle of cynical, chiaroscuro crime dramas we now call film noir.

What makes a film noir? You know it when you see it. These are stories of the ambitious, the greedy, the gamblers, the debauched or the plain psychopathic. Such anti-heroes might be career criminals, or they might be average men and women caught in a weak moment (like Muybridge). They're the types of people described in Herbert Asbury's popular 2002 San Francisco history *The Barbary Coast*, which was the genesis of a 1935 Howard Hawks movie, but with fashions and flourishes updated for the mid-twentieth century. In any case, they're doomed. Good noirs rarely conclude happily. Those that do leave the audience wondering if a Hollywood ending for its characters could last into an imaginary next reel.

In *Fallen Angel* (Otto Preminger, 1945), Dana Andrews drifts into a coastal town in California and immediately falls in lust with waitress Linda Darnell, a classic femme fatale with aspirations of material comfort far beyond his means – at first. He lures heiress Alice Faye to San Francisco on the false pretext of a Toscanini concert at the Civic Auditorium. He quickly marries her, intending to prove his worth to Darnell through his access to Faye's bank account. But becoming a murder suspect fouls his plans. That the film finishes with his name cleared, his financial and romantic life secured, doesn't convince us that Andrews has truly redeemed himself. It's a profoundly unsettling happy ending.

More typical is the finale of Jacques Tourneur's 1947 *Out of the Past* (aka *Build My Gallows High*). Here Robert Mitchum's link to his own femme fatale, Jane Greer, is severed only through self-annihilation. These two films spend more time

Above © 1947 Columbia Pictures Corporation
Opposite © 1950 Jack M. Warner Productions

out of San Francisco than in it, but in each, the city looms over the entire narrative, representing romance and deception, freedom and avarice.

If the value of a city to film noir comes from its contrasts and contradictions, then San Francisco physically emphasizes these more than most municipalities. With Los Angeles building height limits in effect until 1956, San Francisco was the only West Coast city during the classic noir era with enough structures over 150 feet high to evoke the claustrophobia of a modern city's towering corridors. What's more, its skyscrapers have a socio-geographic mirror in the famous hills the city is built upon and between. At the top of both we find socialites and captains of industry; at the bottom, proletariat slum denizens and wharf rats.

Spatial considerations became increasingly important after the post-World War II vogue for 'semi-documentary noir'. Cinematic cities were no longer constructed only out of stock footage and back-projection (as the San Francisco of *The Maltese Falcon*, *Fallen Angel* and *Out Of The Past* was), but by bringing actors onto real locations when the budget afforded it. Soon, dozens of productions seeking verisimilitude came to San Francisco, including *Dark Passage* (Delmar Daves, 1947), *Born To Kill* (Robert Wise, 1947), *Thieves' Highway* (Jules Dassin, 1949), *D.O.A.* (Rudolph Maté, 1950), *Woman on the Run* (Norman Foster, 1950), *The Man Who Cheated Himself* (Felix E.

Feist, 1950), *Sudden Fear* (David Miller, 1952) and *The Sniper* (Edward Dmytryk, 1952).

All of these films employ San Francisco's verticality to visually emphasize a gap between wealth and poverty that the unscrupulous may see as an open window to climb through. None do so more despairingly than *Shakedown* (Joseph Pevney, 1950). Howard Duff plays San Francisco's most enterprising and amoral photojournalist, who rises from the Embarcadero pavement to the city centre as his career climbs. His steepest ascent is from outside the Kearney Street entrance to the Hall Of Justice, where he flatters Brian Donlevy's picture-shy mob boss into letting him be his personal PR plant at the newspaper he works for. In this San Francisco, crooks dwell not in the underworld but in penthouses, where they can better display prizes such as Donlevy's high-class wife. Duff's camera becomes one more weapon in the gangster's arsenal.

In the mid-1950s, the use of San Francisco as a noir location began to decline. Partly this was because noir was changing into something else. By 1958, San Francisco films like Alfred Hitchcock's *Vertigo* (a Technicolor spectacular) and Don Siegel's *The Lineup* (a television spin-off police-procedural) resemble noir but don't quite fit with the earlier wave. But San Francisco was changing too. No longer just another American city with a colourful history, it was on its way to being the capital of western counterculture, and undergoing demographic shifts that made the concerns of lily white Hollywood seem incongruous.

Beat poet Christopher Maclaine's experimental film *The End* (1953) derives its title from atomic-age anxiety, but writes an epitaph for San Francisco noir as clearly as its foreboding voice-over and its images of besuited young men running down Telegraph Hill streets and stairways, or lurking in North Beach doorways, echo it. Of the more recent neo-noir cycle (*The Conversation* [Francis Ford Coppola, 1974], *Zodiac* [David Fincher, 2007], etc.) the film that most fruitfully references the post-war noir era is Wayne Wang's 1982 detective story *Chan Is Missing*. Wang strips the Chinatown of *The Lady from Shanghai* (Orson Welles, 1947) and *Impact* (Arthur Lubin, 1949) of its exotic mystique, replacing it with a more complicated mystery, which fans out into the varied Chinese communities throughout the city. It's a reminder that, though San Francisco has always been a place of self-reinvention, in noir you can never escape your nature. ✛

Many films employ San Francisco's verticality to visually emphasize a gap between wealth and poverty that the unscrupulous may see as an open window to climb through.

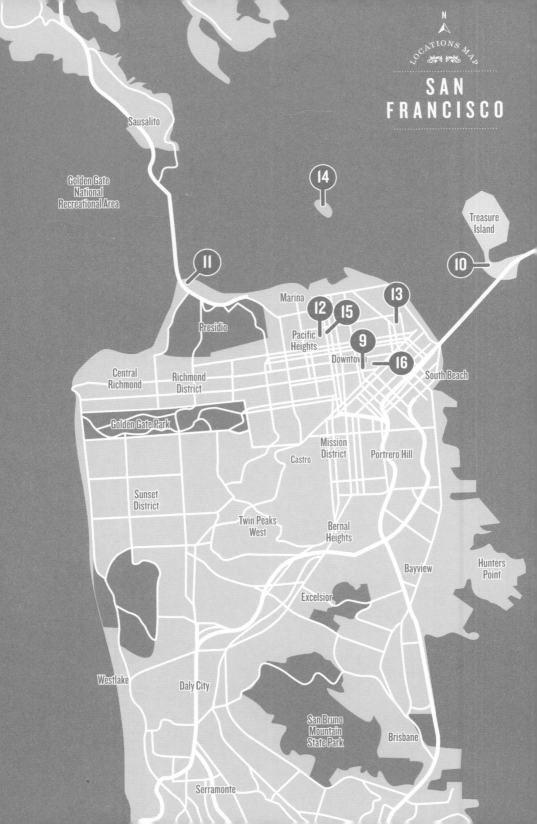

SAN FRANCISCO LOCATIONS

SCENES 9-16

9.
ALL ABOUT EVE (1951)
The Curran Theater, 445 Geary Street
page 32

10.
THE CAINE MUTINY (1954)
Treasure Island Naval Base,
Treasure Island, San Francisco Bay
page 34

11.
IT CAME FROM BENEATH THE SEA
(1955)
(A studio model of)
The Golden Gate Bridge, Golden Gate
page 36

12.
PAL JOEY (1957)
The Spreckels Mansion,
2080 Washington Street
page 38

13.
VERTIGO (1958)
(A Hollywood recreation of the Ambrosia
Room at) Ernie's, 847 Montgomery Street
page 40

14.
BIRDMAN OF ALCATRAZ (1962)
Exterior of Alcatraz Federal Penitentiary,
Alcatraz Island, San Francisco Bay
page 42

15.
DAYS OF WINE AND ROSES (1962)
1800 Pacific Avenue,
between Franklin and Gough Streets
page 44

16.
THE BIRDS (1963)
Union Square
page 46

maps are only to be taken as approximates

ALL ABOUT EVE (1951)

LOCATION *The Curran Theater, 445 Geary Street*

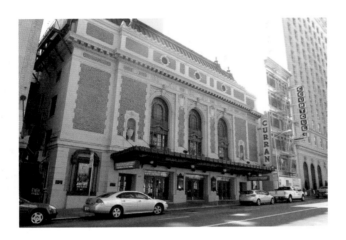

ALTHOUGH *ALL ABOUT EVE* is the definitive film about Broadway, the theatre at which so much of its action takes place is not in New York but San Francisco. An hour into the film, the great American stage actress Margo Channing (played by the great American film actress Bette Davis) sweeps through the door of the Golden Theatre on New York's West 45th Street. But, when we cut inside to see her enter, we are suddenly in the foyer of the Curran Theatre on San Francisco's Geary Street. Here begins a classic scene, or rather three classic scenes. In the first, which briefly features a young Marilyn Monroe, Channing learns from theatre critic Addison DeWitt (George Sanders) that she has missed the audition at which she was supposed to assist. Even worse, her place was taken by Eve Harrington (Ann Baxter), who she fears is aiming to usurp her and who, Addison says, performed brilliantly in Margo's role. Margo moves from the foyer to the auditorium and, in the second successive classic scene, pretends not to know anything Addison has just told her. This leads to an eruptive argument with playwright Lloyd Richards (Hugh Marlowe) and then to a third unforgettable scene, in which Channing's boyfriend, director Bill Sampson (Gary Merrill), breaks up with her, leaving Margo sobbing onstage. It is fitting that the Curran hosted this battle between Margo and Eve, two great Broadway witches: fifty years later, in real life, it would host the first performances of the musical *Wicked*.
Scott Jordan Harris

Directed by Joseph L. Mankiewicz
Scene description: Broadway comes to San Francisco
Timecode for scene: 1:00:37 – 1:13:04

THE CAINE MUTINY (1954)

LOCATION *Treasure Island Naval Base, Treasure Island, San Francisco Bay*

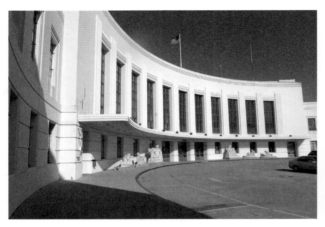

TREASURE ISLAND NAVAL STATION is the setting for the trial at the end of *The Caine Mutiny* and demonstrates the, albeit reluctant, cooperation by the US Navy with a film that depicts both the mental breakdown of a Navy officer and a mutiny against his tyrannical actions. Edward Dmytryk was one of the 'Hollywood Ten' who suffered at the hands of the HUAC investigations of the McCarthy era, and though he did subsequently name names, his reputation survived and his career recovered to the extent that he was given the reins to this movie. A prominent anti-McCarthy activist, Humphrey Bogart (Lt Commander Queeg) had distanced himself from the Hollywood Ten in the years since the height of the persecutions; any film featuring a trial will have an added frisson for audiences aware of this history. Given the facility that Dmytryk had shown in earlier movies for stark stylization and dramatic lighting, his use of the Naval Base is an intriguing one. It is a reclaimed island in San Francisco Bay, but the main use of the location is the view it affords of the bay from the room where the trial takes place. As men are on trial for their lives, a clear and beautiful exterior is visible in many shots. When decommissioned by the Navy, the island hosted sound stages for the film industry from the 1980s. It is named for Robert Louis Stevenson, who was briefly resident in San Francisco. **◆David Bates**

Photos © Gabriel Solomons

Directed by Edward Dmytryk
Scene description: The trial of the mutineers
Timecode for scene: 1:25:12 – 1:52:01

 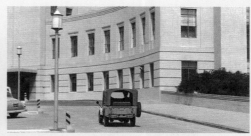

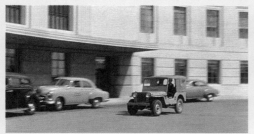 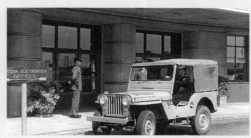

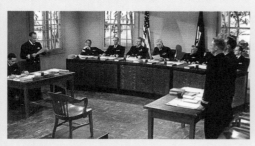 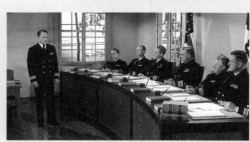

 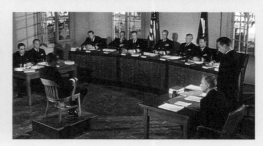

IT CAME FROM BENEATH THE SEA (1955)

LOCATION *(A studio model of)* The Golden Gate Bridge, Golden Gate

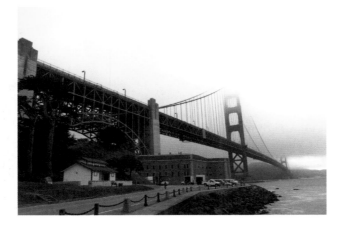

ROBERT GORDON'S 1950S CREATURE FEATURE *It Came From Beneath the Sea* was one of a multitude of science fiction films of the era that worked on two levels: as popcorn entertainment and as an analogy of social anxieties. Superficially, *Beneath the Sea* is the fantastical tale of a giant radioactive Octopus creating havoc around the coast of America. At a deeper level, Gordon's movie, like Ishiro Honda's *Gojira* (1954), reflected deeply held concerns about the Atomic Age, when the threat of widespread military destruction or the possible outcomes of a nuclear accident were never far from the minds of the general populace. Designed as a showcase for the stop-motion animation effects of Ray Harryhausen, dubbed 'Dynamation' by Hollywood's buzzword-friendly marketing men, *Beneath the Sea* features key scenes shot on location in and around San Francisco. After hydrogen bomb testing disturbs and irradiates a giant cephalopod in the depths of the ocean, San Francisco comes under attack from the monstrous creature. The city's iconic Golden Gate Bridge, a globally recognized landmark, is used to show the scale of the problem facing the US military and civilization as a whole. Harryhausen's ground-breaking scale model effects are combined with actual location footage, through editing and super-imposition, to show the creature scaling and destroying one of the sections of the 227 metre-high bridge. In Gordon's movie, the Golden Gate Bridge signifies the threshold between safety and danger, and between the known and the unknown. ⦿ *Neil Mitchell*

Directed by Robert Gordon
Scene description: The sea monster destroys the Golden Gate Bridge
Timecode for scene: 0:55:52 – 1:00:44

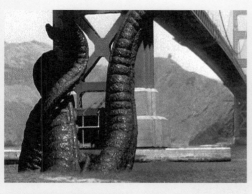
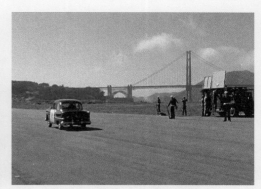

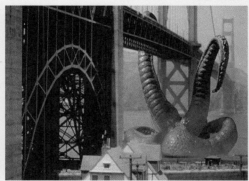

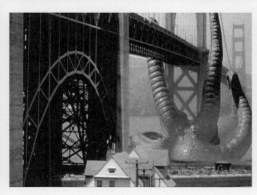
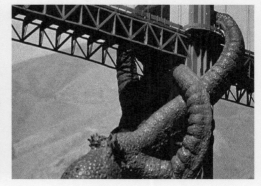

PAL JOEY (1957)

The Spreckels Mansion, 2080 Washington Street

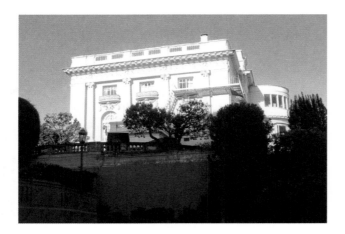

HAVING WORMED HIMSELF into the affections of wealthy former showgirl Mrs Vera Simpson (Rita Hayworth), Frank Sinatra's low-rent lothario, Joey Evans, has graduated from his job as compère at the dingy Barbary Coast club to proprietor of his own establishment: the palatial Chez Joey, 'San Francisco's smartest supper club' – which is, he gleefully points out, located 'way up [on] Nob Hill'. In this scene, we see him driving up to inspect the premises ahead of its grand opening. The camera shows us the building from above, below and each side. It is breathtaking from every angle. Parking his car, Joey stands and drinks in the stunning Beaux Arts exterior and, seeing that this name is now displayed outside it, blows a kiss signalling 'perfection'. It is difficult to disagree. The building is an unbelievably beautiful setting for a nightclub, which explains why, in real life, it isn't one. Instead, it is the famous Spreckels Mansion. Built in 1913, it was home to sugar magnate and racehorse breeder Adolph B. Spreckels and his wife, Alma, who was known as 'The Great Grandmother of San Francisco' because of her philanthropy and her prominence on the city's social scene. Adolph and Alma would not, though, be the last prominent San Francisco residents to live in the mansion. It now belongs to one of America's best-selling novelists, Danielle Steel, a fittingly famous owner of a house so opulent it carries the nickname 'The Parthenon of the West' and was declared San Francisco's 'Best Mansion' by *SF Weekly* in 2008. **•◦Scott Jordan Harris**

Photo © Gabriel Solomons

Directed by George Sidney
Scene description: Welcome to Chez Joey
Timecode for scene: 1:04:29 – 1:05:20

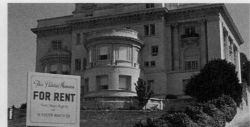

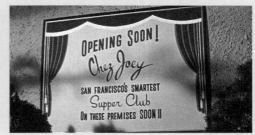

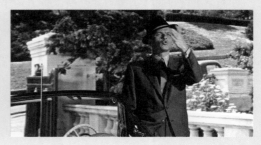

VERTIGO (1958)

(A Hollywood recreation of the Ambrosia Room at) Ernie's, 847 Montgomery Street

FORMER DETECTIVE SCOTTIE FERGUSON (James Stewart) is asked by Gavin Elster (Tom Helmore) to protect his wife, Madeleine (Kim Novak), by shadowing her movements. The iconic sequence in which Madeleine Elster first appears on-screen occurs at the legendary Ernie's, an haute cuisine establishment in San Francisco. Hitchcock selected Ernie's for this memorable cinematic encounter as it was his favourite restaurant in the City by the Bay; in fact, it is where he hosted *Vertigo*'s post-premiere party. In this scene, as Scottie waits at the restaurant's bar, the camera pans across Ernie's famous Ambrosia Room, and then tracks forward to the Elsters, who are dining there. As they exit, they pass Scottie. Madeleine's beautiful profile, framed in close-up, appears illuminated by the restaurant's crimson wallpaper, emblematic of the elusive allure of Hitchcock's intriguing blondes. For *Vertigo*, Ernie's Ambrosia Room was reconstructed at Hollywood's Paramount Studio, including the restaurant's original china, silverware and linens, as well as its red silk damask wallpaper with a floral motif. Ernie's real-life maître d' and bartender were cast in these very roles, lending even more authenticity to the recreation. This early scene is the first of several featuring Ernie's, a location to which Scottie returns in his obsessive quest for Madeleine. Initially a trattoria named Il Trovatore Café, the restaurant would go on to become the five-star Ernie's, catering to the well-heeled, important and famous, until it closed in 1995. **Marcelline Block**

Directed by Alfred Hitchcock
Scene description: Scottie first glimpses Madeleine at Ernie's
Timecode for scene: 0:17:59 – 0:19:39

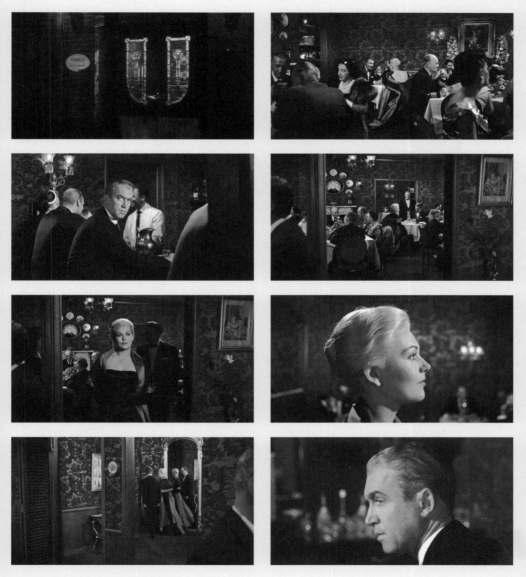

Images © 1958 Paramount Pictures, Alfred J. Hichcock Productions

BIRDMAN OF ALCATRAZ (1962)

LOCATION *Exterior of Alcatraz Federal Penitentiary, Alcatraz Island, San Francisco Bay*

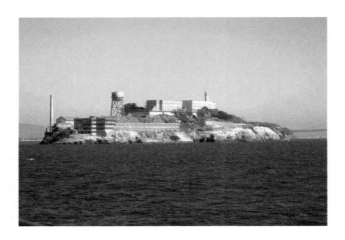

THERE WASN'T REALLY A BIRDMAN OF ALCATRAZ. Robert Stroud conducted all of his famous ornithological studies at Leavenworth Prison and wasn't allowed to have birds in Alcatraz. But John Frankenheimer cannily (and some might say cloyingly) uses the misconception to elegiac effect. A final shot of the canaries belonging to Stroud (Burt Lancaster) gently fades out to his first glimpse of Alcatraz, and while the parallel is obvious (Alcatraz is humanity's most famous cage, and a crueller one for this particular 'bird'), it is still bitterly effective. For half the film, we've been treated to the whirling, the chirping and the messy sights of Stroud's makeshift aviary. He and his canaries are confined, but they are alive, and the birdsong makes even a dark cellblock feel warm. This isn't the first shot of Alcatraz in *Birdman*. The film opens with it framing our narrator, but it never feels part of the story until now, when it breaks into Stroud's confinement with a marvellous expanse of sea and sky. The infamous fortress chills the view with its sullen sprawl. Stroud never even glances at his new prison, but his defiance seems diminished by its antiseptic shadow. We never see or hear a single bird – not even a gull! – during this painful transfer, and the absence is deliberate, particularly for a place that used to be called Bird Island. Alcatraz Island is a grim delineator of Stroud's life. He never looks back on his beloved birds but instead turns to writing about the inhumanity of prisons. **Elisabeth Rappe**

Directed by John Frankenheimer
Scene description: Robert Stroud arrives at Alcatraz by boat
Timecode for scene: 1:43:56 – 1:45:02

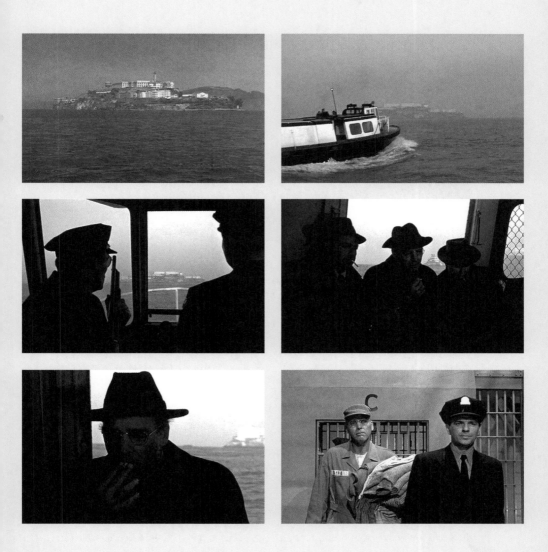

DAYS OF WINE AND ROSES (1962)

1800 Pacific Avenue, between Franklin and Gough Streets

THE SUN IS SHINING OUTSIDE on the streets of San Francisco as Joe Clay (Jack Lemmon) heads home to his apartment. His lovely wife, Kirsten (Lee Remick), awaits him as she tends to their baby girl. Their abode is large, fabulously chic with its elegant adornments and supremely located, with a Golden Gate vista. Yet all of their home's pretty decorations belie a tragedy waiting to unfold, particularly with the number of drinking glasses in full, crystal-clear display. It is here at 1800 Pacific Avenue that director Blake Edwards introduces the film's pivotal point. This lovely abode with its highest of comforts is the stage for this family's fall. The next time we see the Clay residence is perhaps close to midnight, and the contrast to Joe's earlier sunny reverie could not be starker. Inebriated and stressed out due to the ethics of his work (or more precisely the lack of them), he oafishly and comically heads home. His foolishness is somewhat softened by the knowledge that this is Jack Lemmon playing our protagonist, the jovial everyman with whom everyone loves to laugh. But any hints of joy quickly disappear as his drunken stupor turns into insensitivity and rage as he pours out his frustrations on his family as loosely as he pours his drink. The stage has been set, no longer enviable as it first appeared. Joe wonders why he finds two bottles instead of three. Their apartment goes up in flames, as do their fortunes.
➻Michael Mirasol

Directed by Blake Edwards
Scene description: Joe Clay returns to his apartment
Timecode for scene: 0:38:18 – 0:39:28

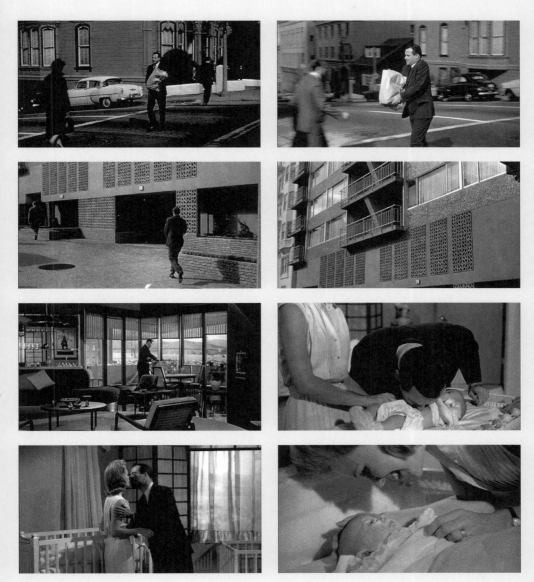

THE BIRDS (1963)

Union Square

HITCHCOCK OFTEN MADE A POINT of removing his characters from the comfortable modernist certainty of city settings to less predictable rural climes in an effort to introduce peril. In *The Birds*, before dispatching Melanie Daniels (Tippi Hedren) on a little trip to the Pacific coastal wilds of Bodega Bay nearly seventy miles north of San Francisco, he shows her in her natural environment but manages to subtly presage the avian terrors to come. A brief opening pan shot of Union Square captures the urban bustle from which the relaxed, confident and well-dressed Melanie emerges. The plaza, built in 1850, is at the heart of the city's shopping, dining and theatre district and Melanie's demeanour perfectly reflects this metropolitan sophistication. The shot features a glimpse of the Dewey Monument at the centre of the square, a 30-metre granite column topped with the bronze statue of Victory erected in 1903 to commemorate Admiral George Dewey's victory at the Battle of Manila Bay during the Spanish American War and the assassination of US President William McKinley. Green with patina, unusually wingless and with arms raised waving her trident and wreath amid a large flock of birds above the square, the sculpture foreshadows the mythically beautiful Melanie, dressed in the eau de Nil suit that Hitchcock insisted she wear in every scene except the film's opener, flailing a flashlight as she attempts to fight off the winged menace that attacks her in the attic during the film's final reel.
⇨ Jez Conolly

Directed by Alfred Hitchcock
Scene description: The socialite sees a portent of her fate
Timecode for scene: 0:01:42 – 0:02:16

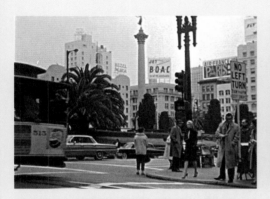 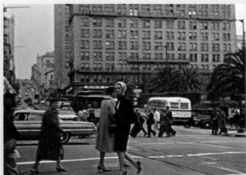

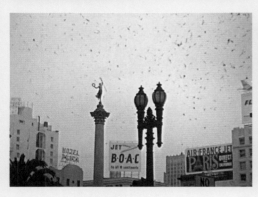 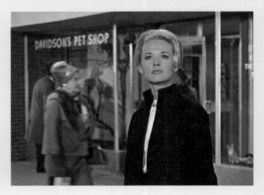

ALFRED HITCHCOCK PRESENTS SAN FRANCISCO

SPOTLIGHT

The Master and the City by the Bay

SOON AFTER LEAVING for Hollywood in 1940, English director Alfred Hitchcock found so much comfort in Northern California and the San Francisco Bay Area's familiar cool, moist weather and picturesque coastline that he and his wife, Alma, bought a getaway home in Scotts Valley, nestled in the Santa Cruz Mountains. That same year several scenes for his Oscar-winning *Rebecca* were shot in nearby Point Lobos, representing the Cornwall coast.

There are three key Hitchcock films in which San Francisco Bay Area locations become characters themselves: *Shadow of a Doubt* (1943), set and partially shot in Santa Rosa; *The Birds* (1963), which helped put Bodega Bay on the map; and then, most crucially, the film voted first in the 2012 *Sight & Sound* poll, *Vertigo* (1958), which uses San Francisco as few others have.

Shadow of a Doubt is set in Santa Rosa, north of 'the City', fitting for the film's small town Americana gothic-noir. *Shadow of a Doubt* centres around the Newtons: frumpy Henry Travers as the murder mystery-loving patriarch; stage actress

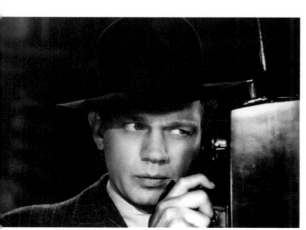

Patricia Collinge as the earnest mother; and young, ennui-ridden Charlie (the lovely Teresa Wright), named after her beloved but suspect uncle (Joseph Cotten), whose visit will leave the family forever changed.

While most of the interiors were filmed in a studio, Hitchcock used Santa Rosa for numerous location shots, including the public library, downtown streets and the Newton family house, bright-white but shaded by trees, filtering in just enough darkness to foreshadow sinister tidings. There's quaint charm, too, in seeing Uncle Charlie arrive and leave for San Francisco by train from Santa Rosa; the station is now a tourist centre.

In *Vertigo*, Hitchcock uses a mix of atmospheric Bay Area locations that work in tandem with the film's plot of romantic obsession, of chasing imagined ghosts. With its precipitous hills, high-reaching buildings and sweeping vistas, San Francisco is the perfect setting, and right from the start the city is used to dizzying effect with the chase through the rooftops (actually filmed in a Hollywood studio, but using San Francisco footage as a well-integrated backdrop) that gives Jimmy Stewart's Scottie the titular affliction.

Scottie is sent by an old acquaintance, Gavin Elster (Tom Helmore), on a wild ghost chase to follow Elster's wayward wife, Madeline (Kim Novak). The film's use of, and references to, actual urban locations was, for a studio film, rare for the time. Scottie spies on Madeline at famous downtown eatery Ernie's, with its red velvet walls and formal-patrons, then tracks Madeline to a series of haunts: a Union Square flower shop; 300-year-old Mission Dolores, still intact and in use, where Scottie first learns of her obsession with 'Carlotta Valdes', buried at the Mission; the bluff-top Legion of Honor museum where Madeline stares at a painting of Valdes; the tenebrous McKittrick Hotel (actually the Portman Mansion

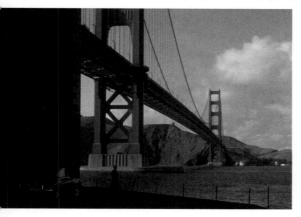

on Gough Street), an 1890s Western-Gothic Victorian building into which Madeline wanders. All of these and other featured locations reflect the city's historically diverse layers.

1950s San Francisco had become the eleventh largest city in America, with 775,000 inhabitants (interestingly, it would have roughly the same population 50 years later). *Vertigo* captures the post-war urbanity and the city's transitional attempts at sophistication, the conflict between its old-world past and pending future-scape. It exists in geography both real and dream-infused. Midge (Barbara Bel Geddes), the ex-fiancée who lives in a hip Telegraph Hill studio, an artist turned ad illustrator, seems to reflect the more modern San Franciscan to Scottie's forcibly retired cop – yet she's also a practical and maternal figure whom Scottie rejects.

Madeline's case and the Valdes red herring drive Scottie into a newfound interest in local history. He heads to the musty 'Argosy Book Shop', located at a non-existent Powell Street address and purport-edly based on two nearby bookstores; of one, the Argonaut, Hitchcock supposedly said, 'Now this is what a bookstore should look like.'

In *Vertigo*, Hitchcock uses a mix of atmospheric Bay Area locations that work in tandem with the film's plot of romantic obsession, of chasing imagined ghosts.

Vertigo uses other Bay Area locales to great effect, including Big Basin (near Hitchcock's vacation home), where Madeline has a breakdown among ancient redwoods, triggered by the overwhelming nature of time. Then, famously, there is the drive 90 miles south to Mission San Juan Bautista – although the haunting route through the dappled shade of eucalyptus trees is actually just south of there, and the church's bell tower was added via matte painting.

Once one knows *Vertigo*'s Lombard Street-like twists, one can appreciate (and admittedly question) other elements – including the impressive details that Gavin goes through to weave his web of deceit, and the levels of psychological deception. Fitting for a unique city that has constantly reinvented its own colourful history.

Hitchcock would return to Northern California five years later for *The Birds*, which begins in San Francisco before shifting to the Sonoma Coast's Bodega Bay. Melanie drives north via the cinematically curvy Highway 1 (using the magic of rear projection and location footage), which her caged lovebirds take in stride. Besides expanding the town of Bodega Bay itself with mattes in wide aerial shots, Hitchcock embellished geographically another key way, using the adjacent inland community of Bodega for both schoolteacher Annie's (Suzanne Pleshette) house and the school itself, the setting for one of the film's most famous sequences, as terrified children flee an attacking flock. Annie has her own San Francisco, having fled to Bodega because her failed relationship with Rod Taylor's Mitch, while he leaves every weekend to escape his caseload of 'hoods' in the city he calls 'an anthill at the foot of a bridge'.

While most of the horror is focused in Bodega Bay, at the end there are hints that the avian apocalypse has spread to San Francisco and beyond, though not nearly as explicitly as in the original script. Co-writer Evan Hunter and Hitchcock both spoke of originally envisioning the car escape stretched out into a chase and another bird attack, and Hitchcock toyed with the idea of 'a lap dissolve, followed by the Golden Gate Bridge and San Francisco covered in birds'.

Hitchcock would return to Northern California in bits and pieces: the hills of Salinas were used to represent Cuba for the spy thriller *Topaz* (1969); and Hitchcock's final film, *Family Plot* (1976), makes an odd hybrid of Los Angeles and San Francisco locations (including the iconic Grace Cathedral and the Fairmont Hotel) to create a fictionalized sprawling urbanity that is clearly California yet not rooted in any one place. It's a fitting place for Hitchcock to bid farewell, existing in a very real geography that is nonetheless wholly cinematic. ✤

SAN FRANCISCO LOCATIONS

SCENES 17-24

17.
THE GRADUATE (1967)
San Francisco Zoo, 1 Zoo Road
page 52

18.
BULLITT (1968)
San Francisco General Hospital,
1001 Potrero Avenue
page 54

19.
DIRTY HARRY (1971)
Muni Metro K Car and Mission Dolores
Park, Mission District
page 56

20.
HAROLD AND MAUDE (1971)
The ruins of the Sutro Baths,
on the Pacific Coast, near Seal Rock
page 58

21.
PLAY IT AGAIN, SAM (1972)
A San Francisco cable car
page 60

22.
WHAT'S UP DOC? (1972)
San Francisco Hilton Hotel (now the
Hilton San Francisco Union Sqaure),
333 O'Farrell Street
page 62

23.
AMERICAN GRAFFITI (1973)
The former Mel's Drive-In, corner of
South Van Ness and Mission Street
page 64

24.
THE CONVERSATION (1974)
One Maritime Plaza
(originally the Alcoa Building),
250 Clay Street
page 66

maps are only to be taken as approximates

THE GRADUATE (1967)

San Francisco Zoo, 1 Zoo Road

FOR MUCH OF *The Graduate*'s running time, there is that swimming pool, a metaphor for Ben Braddock's not-so-subtle fear of being trapped (just like his pet fish). His parents and their assortment of family friends seem to have set up all the opportunities for Ben (Dustin Hoffman) to take advantage of upon his return from university. But for whatever reason, good or bad, he feels stifled by them. Call it cluelessness or rebellion. Ben wants his future to be 'different'. So it shouldn't surprise us when director Mike Nichols shows him fighting for his fate at the San Francisco Zoo. Ben tags along with Elaine Robinson (Katherine Ross), the girl he loves and the daughter of that most famous of older women, Mrs Robinson (Anne Bancroft). He knows that she is meeting a date, yet still has the persistence to stick around to jealously see who Elaine is seeing, all in an effort to win her back. Upon meeting her beau, Carl (Brian Avery), Ben realizes, perhaps along with the audience, that he will get her back. Carl's prim, proper and professorial manner just doesn't jive with the sparks that both Ben and Elaine emit. But, just like the animals around him, Ben will have to use his instincts to ensure that their relationship survives. Idealistic, headstrong, and away from the cosiness of college life and the creature comforts of home, he is truly on his own. Talk about a fish out of water. ➛*Michael Mirasol*

Photos © Gabriel Solomons / The former site of Monkey Island

Directed by Mike Nichols
Scene description: A rendezvous at the zoo
Timecode for scene: 1:16:14 – 1:17:53

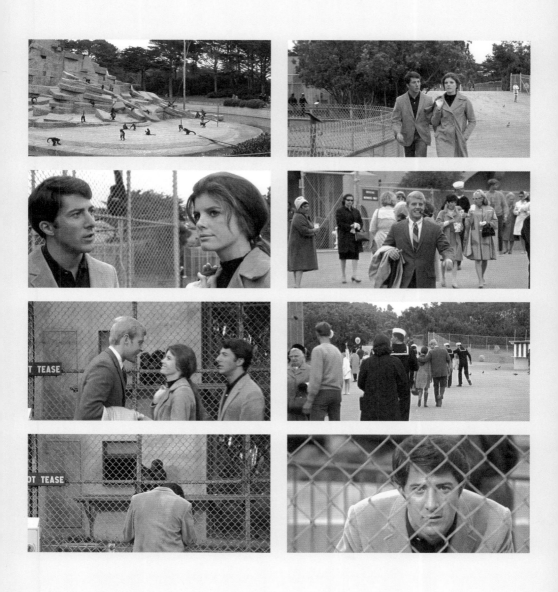

BULLITT (1968)

LOCATION *San Francisco General Hospital, 1001 Potrero Avenue*

WHEN IT COMES TO MOST MOVIE HOSPITALS, the last thing you think about is liveliness, as most of them are depicted as bland and depressing places to be sick or die. But *Bullitt*'s San Francisco General Hospital, at 1001 Portero Avenue, is remarkable for how alive it is through its architectural design, authenticity and atmosphere. Gone is the overbearing whiteness common in other films, as earthier tones of brown, beige, tan and green are in abundance. Actual staff, from nurses to doctors, participated in scenes, adding a more grounded and realistic feel to medical proceedings. Correct and proper medical and operating procedures were strictly adhered to for accuracy. Even the look of the hospital itself feels unique, with its striking brownish brick-layer exterior. Its corridors, poorly lit stairways, and other seldom-seen nooks and crannies add even more tension to the cat-and-mouse chase that occurs within, particularly when it leads to a foreboding basement tunnel. Old doors and decrepit areas are not masked to look shiny and new. The clinic's age is showing as it should. Today, when hospitals in film are staged mock-ups designed to be cold and clinical, it's terrific to see a real-life medical centre in all its vivacity. Like San Francisco itself, *Bullitt* uses San Francisco General Hospital's most notable physical qualities to reveal something rare: character.
❖ Michael Mirasol

Directed by Peter Yates
Scene description: A visit to San Francisco General
Timecode for scene: 0:25:39 – 0:32:00

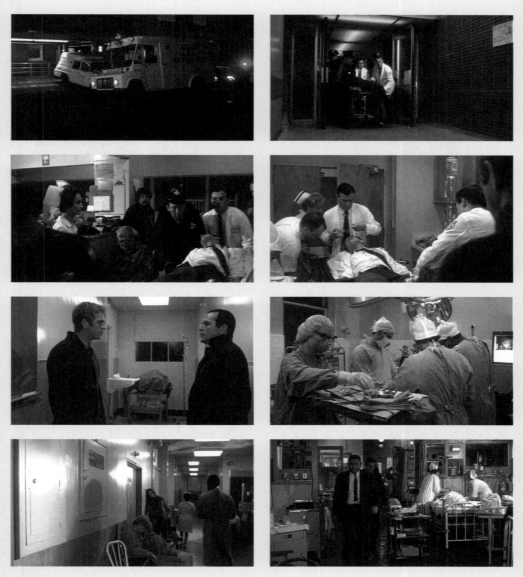

DIRTY HARRY (1971)

Muni Metro K Car and Mission Dolores Park, Mission District

SCORPIO (ANDREW ROBINSON) has claimed three victims. He's kidnapped, tortured and buried alive a teenage girl, promising to release her if San Francisco pays the ransom. A cowed city agrees, sending Inspector 'Dirty' Harry Callahan (Clint Eastwood) out as bagman. But Callahan is determined to bring the madman in. He puts on a wire, with his partner, Chico (Reni Santoni), listening and following from a distance, tapes a switchblade to his calf and holsters his trusty .44 Magnum. What follows is one of the most nail-biting sequences in *Dirty Harry* as Scorpio sends Callahan running all over the streets of San Francisco, hailing him by payphones, which he must answer by the fourth ring or the girl dies. He sends Harry for a trip on the K car, which puts him out of contact with Chico. It's a painfully long ride in which we, Harry and Chico must wonder if Scorpio will attack our weary cop as he winds under city streets. But Scorpio intends it to be a break – not that Callahan relaxes his tight jaw for a moment – and Harry surfaces at Mission Dolores Park, allowing us to take a relieved breath together. Harry survives to answer another phone, and Scorpio's victim is closer to rescue. Or is she? Scorpio's growing more confident and cruel, taunting Harry with insults. Harry may be perched on Forest Hill, but he has no vantage point. He's blind and vulnerable, garishly lit by the booth's light, the perfect target against a black expanse. ➔ *Elisabeth Rappe*

Directed by Don Siegel
Scene description: Harry hurries to a payphone above Mission Dolores Park
Timecode for scene: 0:49:15 – 0:51:32

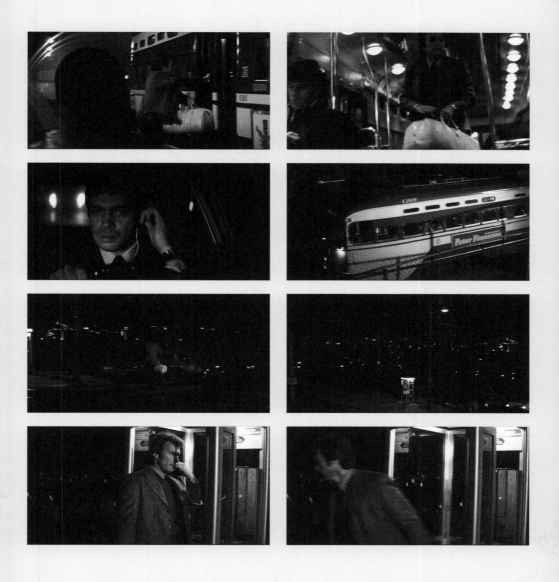

HAROLD AND MAUDE (1971)

LOCATION *The ruins of the Sutro Baths, on the Pacific Coast, near Seal Rock*

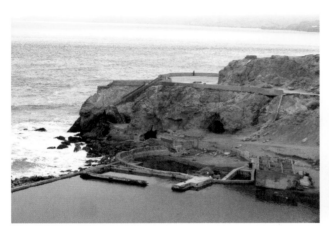
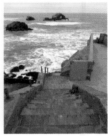

THE SWIMMING BATHS PORTION of the Sutro Baths had actually burned down a few years before *Harold and Maude* is set. Unlike most ruins, which are usually surrounded by anything that suggests civilization, the Sutro Baths are all wilderness: jagged cliffs eroded from millennia of violent collisions with Pacific waves; the shore unkempt and perilous; and the sprawling, rustic hills illustrating that this landscape will not be tamed. In this scene, Harold (Bud Cort) pretends to be enthusiastic about joining the army, which his uncle Victor (Charles Tyner), a decorated general, would arrange. He then feigns a murderous obsession for Victor's benefit. When Maude (Ruth Gordon) appears posing as a one-woman peace rally, she and Harold stage a struggle in which she fakes her own death, wiping out any desire Victor had of enlisting his nephew. What makes this scene significant is how it cements Harold and Maude's partnership, and their rebellion against social norms. It's the first time Harold isn't just along for the ride as a reluctant, albeit enthralled, observer. Realizing they're the same, he and Maude team up for a common goal. It's afterwards that they consummate their affair. Much like the ruins are in stark contrast to their natural settings, the anarchic pair fend off Victor, who is a palpable personification of order. To ironically punctuate the scene, Maude uses her 'fighting' umbrella to wrestle Harold out of society's grips, while Victor's wire prosthetic – replacing the arm he lost in a war – malfunctions by performing an involuntary salute. **Olivia Collette**

Directed by Mildred Lewis and Colin Higgins
Scene description: An unusual anti-war rally at the ruins of Sutro Baths
Timecode for scene: 1:00:07 – 1:04:90

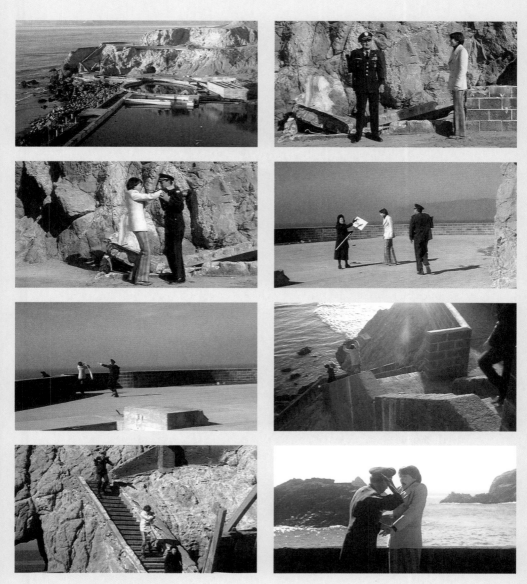

PLAY IT AGAIN, SAM (1972)

LOCATION *A San Francisco cable car*

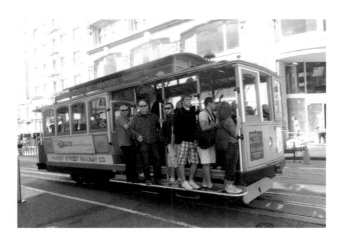

WOODY ALLEN AND DIANE KEATON are one of the great rom-com couples, but we are now so used to seeing them in New York, sitting beneath the Queensboro Bridge or walking along Manhattan streets, that to see them in their first film together standing aboard a Californian icon – a San Francisco cable car – seems jarring and odd. Their characters, Allan and Linda, have fallen in love and are discussing how best to inform Dick, who is Linda's husband and Allan's best friend. It's an excellent scene: Woody's classic nervous babbling plays over a shot of the cable car moving sedately upwards and away from a static camera. It's unsurprising to learn that *Play It Again, Sam* was scheduled to be shot in New York. A strike among film technicians there caused the production to switch to the City by the Bay and, although most of the filming took place indoors, the outdoor scenes make good use of recognizable San Francisco locations. And there are few San Francisco locations as recognizable as its cable cars, which are famously the only American National Monument that moves. The first cable cars opened in the 1870s but faced extinction by the late 1940s, prompting the formation of the Citizen's Committee to Save the Cable Cars; that spirit of conservation has protected them ever since. Though only three cable car routes remain, they form one of the city's most popular tourist attractions. If you visit San Francisco, you simply must take a trolley ride. **•◆Scott Jordan Harris**

Directed by Herbert Ross
Scene description: A cable car named neurosis
Timecode for scene: 1:04:06 – 1:04:48

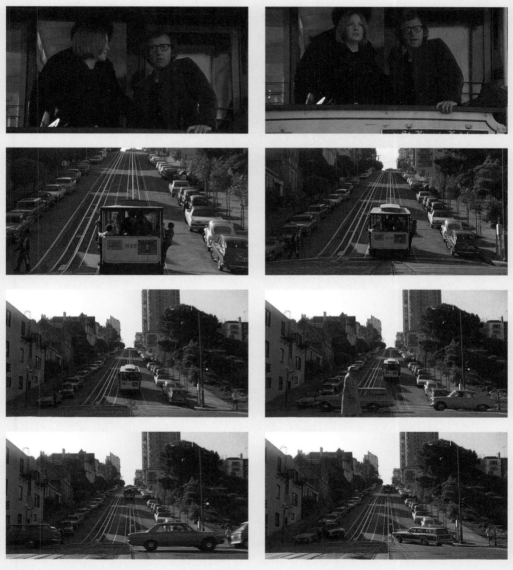

WHAT'S UP DOC? (1972)

*San Francisco Hilton Hotel
(now the Hilton San Francisco Union Sqaure), 333 O'Farrell Street*

THE CAR CRASH ROMANCE between mild-mannered academic Howard Bannister (Ryan O'Neal) and college drop-out Judy Maxwell (Barbra Streisand) in Peter Bogdanovich's souped-up homage to the screwball comedies of the 1930s begins in the relatively anodyne setting of the Hotel Bristol lobby. The hotel is hosting the convention of the Congress of American Musicologists at which Howard will be competing for a $20,000 research grant. Judy's scattershot curiosity (or maybe it's her stomach: she seems to be following a pizza delivery boy into the building) leads her to the location where she quizzes Fritz the desk clerk (Stefan Gierasch) in an attempt to get a room for the night without paying. When this fails, she lingers in the lobby looking out for plan B to present itself. Having helped herself to carrots from a passing tray, Judy spots Howard arriving with his fiancée, Eunice (Madeline Khan), takes a shine to him, and plots her next move. The Hotel Bristol is in fact the San Francisco Hilton Hotel on O'Farrell Street, known today as the Hilton San Francisco Union Square, and at the time of filming was a recently opened single-towered 46-storey skyscraper hotel that Bogdanovich exploited to the full: the lobby, drugstore, ballroom, seventeenth floor and part-finished top floor occupy the first hour of the film. The Hilton's perpendicular formality of fresh paint and elevator muzak provided the perfect setting for its hilariously hectic story of jewel theft, top secret documents, igneous rocks and love amid a plethora of plaid overnight cases. **Jez Conolly**

Directed by Peter Bogdanovich
Scene description: Judy's first sight of Howard in the Hotel Bristol lobby
Timecode for scene: 0:06:43 – 0:10:02

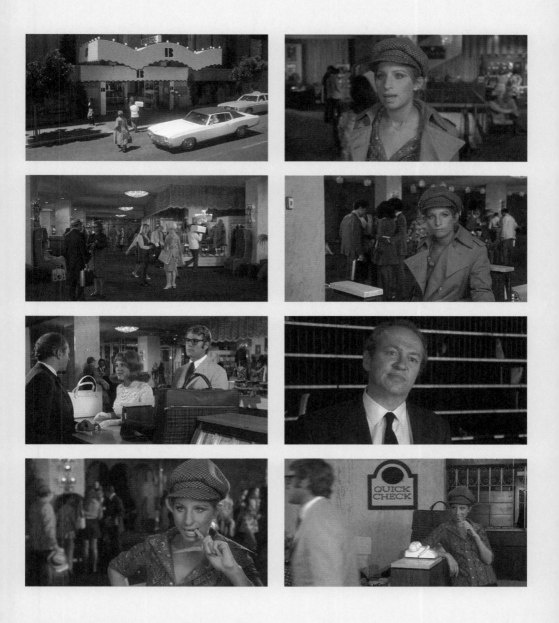

AMERICAN GRAFFITI (1973)

LOCATION *The former Mel's Drive-In, corner of South Van Ness and Mission Street*

ALTHOUGH THE PERIOD WHEN IT IS SET occurred only a decade before it was made, *American Graffiti* is one of film's great period dramas. And its early 1960s setting is evident from its opening shot: the neon-lined exterior of Mel's Drive-In restaurant, with its roller-skating waitresses, French fries, milkshakes and rock 'n' roll. Mel's is, at least for one more night before some of them leave for college, the centre of the world for the film's teenaged characters. The clever Curt (Richard Dreyfuss) agonizes over whether to accept the scholarship he's been given. The sensible Steve (Ron Howard) tells his girlfriend they should see other people while he is away. The hopeless Terry (Charles Martin Smith) pesters a pretty waitress for a date. In one sense, it's a unique occasion; in another, it's just another night at Mel's. Mel's opened in 1947 and soon became a San Francisco landmark. By the 1970s, however, it had drifted into disuse and disrepair. George Lucas leased it for the *American Graffiti* shoot but, just as the film was opening in cinemas, the restaurant was demolished. Astonishingly, at the exact time it became most famous, Mel's ceased to exist. There is, though, a happy ending to its story. In 1985, the son of one of the original owners opened a new Mel's on Lombard Street. This was joined by others, including one at each of the Universal Studios theme parks in California and Florida. So, just like *American Graffiti*, Mel's Drive-In has a sequel. ✦*Scott Jordan Harris*

Directed by George Lucas
Scene description: Everybody comes to Mel's
Timecode for scene: 0:00:18 – 0:08:00

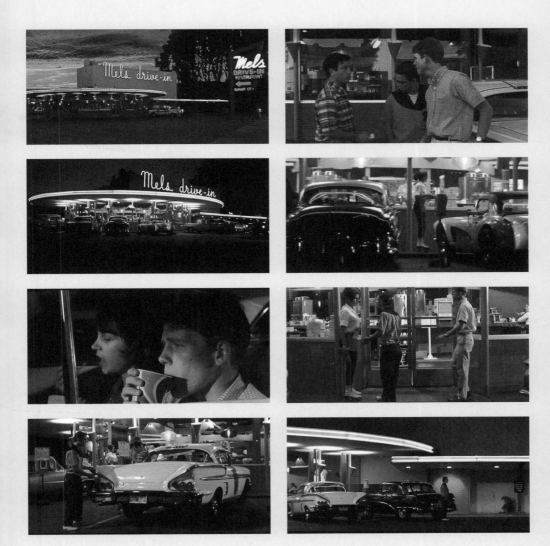

THE CONVERSATION (1974)

LOCATION ⟩ *One Maritime Plaza (originally the Alcoa Building), 250 Clay Street*

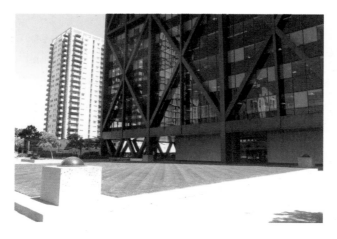

THE CONVERSATION is a masterpiece of guilt and paranoia, emphasizing the feeling of being watched and never being alone. But who does the watching? Is it Harry Caul (Gene Hackman), the film's protagonist, who has masterful surveillance methods but suffers a crippling emotional deficiency? Though Harry bugs, watches and listens, he never comes across as the source of the film's dread. He plays his saxophone with buried passion. He cares deeply for his mistress whom he cannot fully bare himself to. He carries such heavy Catholic guilt that even hearing the Lord's name in vain sets him off. This is a humbled man. He is not only an instrument but also a victim. The film's true menace comes from the powers that be, whatever they may be. In a figurative sense, Harry's employers could easily be interchanged with a criminal organization, a government bureau or any equivalent omniscient figure. In a literal sense, the film's apparent villain is corporate in nature, as the company director and his lackey-like assistant appear to have the worst of intentions for the young couple whose conversation is at the centrepiece of the film. But even this sentiment is no sure thing. In the visual sense, if *The Conversation* has any true representative of an evil pulling the strings, it is the appearance of One Maritime Plaza, or the Alcoa Building as local residents know it. With its striking black facade and cross-cutting steel frame matrix, it cuts an overpowering presence. When Harry Caul exits it, pacing back and forth at its base, his insignificance speaks volumes. •▸*Michael Mirasol*

Directed by Francis Ford Coppola
Scene description: Something awful looms
Timecode for scene: 1:25:48 – 1:26:29

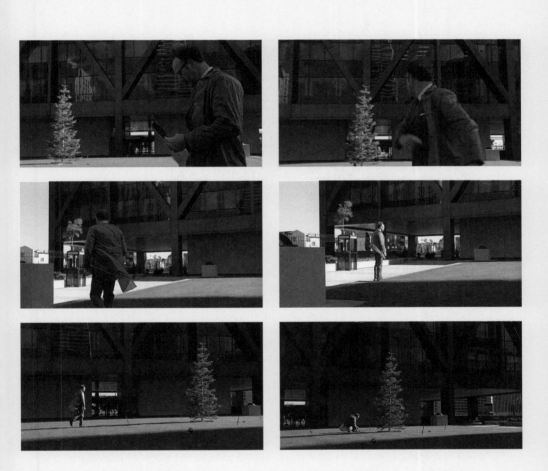

FASTER THAN A SPEEDING BULLITT

Text by
MEL
VALENTIN

San Franciscan Cinema's Famous Car Chases

WE CAN THANK Peter Yates's crime thriller *Bullitt* (1968) for not only revitalizing the American car chase but also for making San Francisco the site for one of, if not the, most famous car chases ever caught on celluloid. Played by the cooler-than-cool Steve McQueen in his prime, *Bullitt*'s eponymous character lived up to his name, obsessively pursuing lawbreakers to what passed for justice in late 1960s San Francisco. A racing enthusiast when he wasn't on set, McQueen successfully lobbied Yates to include an extensive chase scene in and around the surprisingly empty streets of San Francisco. *Bullitt* set the template, the standard by which all car chases filmed in or out of San Francisco would be measured.

In the modern iteration exemplified by *Bullitt*, the car chase embodies the melding of man and machine but, more than that, it embodies the iconic western hero, the laconic, loner lawman, re-

contextualized and re-mythologized as an urban hero. *Bullitt*'s title character is a man of few words: reserved, detached and dispassionate. Like every cop-hero that followed, words mean little to him: his actions are everything. In turn, the chase scene can be seen as the distillation of character into its purest form, pure action and, on another level, pure cinema.

What begins as an almost casual scene with Bullitt spotting two men, professional killers sent to execute a potential mob informant who's fled to San Francisco for sanctuary, tailing his green Ford Mustang in their black Dodge Charger. The pursuers become the pursued; the hunters, the hunted. An almost dizzying chase in and around the streets of San Francisco ensues, culminating in a freeway chase and a fiery explosion. Shot over three weeks and edited into an exhilarating eleven-minute sequence, the chase scene helped Frank P. Keller to an Academy Award for Best Editing. McQueen handled roughly 10 per cent of the sequence. Stunt drivers handled the rest. In a rare on-screen moment, the Dodge Charger's stunt driver, Bill Hickman, appeared as one of the killers.

It didn't take long before another director, Peter Bogdanovich, played the car chase not for un-ironic suspense but for calculated laughs. An avowed fan of Hollywood's Golden Age, Bogdanovich made *What's Up, Doc?* (1972) an attempt to resurrect the screwball comedy with Barbara Streisand as Judy Maxwell, a veritable force of chaotic nature, and Ryan O'Neal as Howard Bannister, a perpetually befuddled musicologist and romantic interest. The serviceable plot, centring on four identical bags, one containing state secrets, another one containing jewels, provides more than an

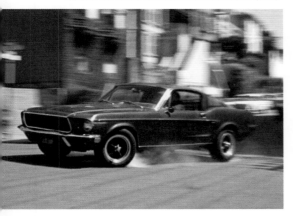

Above © 1968 Warner Brothers/Seven Arts
Opposite © Rutger Myers

adequate excuse for an ever-escalating series of complications.

What's Up, Doc? also features a prolonged chase that begins with Streisand and O'Neal's characters attempting to escape their various pursuers on a bicycle (not a good idea in San Francisco, given the overabundance of hills), followed by a more traditional car-on-car chase scene. Bogdanovich peppers the chase with a plethora of sight gags, including one involving two men attempting to cross a street with a giant pane of glass. Knowing it won't end well is half the fun; the other half is in how and when the giant pane of glass shatters.

Bullitt redefined the car chase and, with it, the cop thriller, implicitly laying down a challenge to future film-makers such as William Friedkin, who attempted to top *Bullitt*'s visceral thrills just three years later when he directed *The French Connection* (1971). Friedkin began a dialogue with *Bullitt* and its contributions to the genre when he consciously decided to include a car chase in *The French Connection*, but it took another director, Sam Peckinpah, to attempt to match or top Yates's car chase with *The Killer Elite* (1975), a lightly regarded crime thriller involving dueling mercenaries played by James Caan and Robert Duvall. Unfortunately, *The Killer Elite*'s car chase at best deserves a passing mention here due to its director and cast, and not because of the originality or novelty of its conception or execution.

> **In the modern iteration exemplified by *Bullitt*, the car chase embodies the melding of man and machine but, more than that, it embodies the iconic western hero...**

Other San Francisco-set car chases deserving a passing mention include the car vs remote-controlled vehicle in the fifth and last entry in the *Dirty Harry* series (Don Siegel, et al., 1971–88), *The Dead Pool* (Buddy Van Horn, 1988); Peter Hyams's 1988 *The Presidio* (an all-but-forgettable crime thriller watchable primarily for Sean Connery's presence); and Paul Verhoeven's *Basic Instinct* (1992). Surprisingly, *Basic Instinct* features not one but two car chases in and around San Francisco, the first in daylight as the central character, a cop with mental health issues played by Michael Douglas, pursues the central character's sports car along Highway 1 (Pacific Coast Highway), and the latter a night-time chase scene memorable only for a car driving up a flight of stairs and the not-quite spectacular demise of a tertiary character.

It took almost three decades after *Bullitt* before Friedkin decided to take it on directly by filming *Jade* (1995), a sub-mediocre entry in the then-popular erotic thriller genre scripted by Joe Esterhas. In probably *Jade*'s one and only highlight, Friedkin reiterated his mastery of the car chase (arguably he did as much as in the far superior *To Live and Die in L.A.* three years earlier) by staging the scene not just during the daytime in San Francisco, but shooting the scene to reflect the city's busy, bustling nature. The crowded streets often slow down the chase to a crawl. At one point, the hero cop played by David Caruso pursues his faceless nemesis into the centre of the Chinese Parade, where bodies fall, before ending in the San Francisco Bay.

At least where the cinematic city of San Francisco is concerned, the car chase reached its apotheosis in 1996. Like Friedkin before him, Michael Bay was mindful of San Francisco's film-making history. The early car chase in *The Rock* (1996) pits a neighbourhood-destroying Hummer driven by Sean Connery's falsely imprisoned, fleeing felon, John Patrick Mason, and a sports car driven by Nicholas Cage's overmatched FBI agent, Stanley Goodspeed. Bay goes all-in, throwing out the laws of gravity (and logic) for a wildly excessive exercise in more-is-most-definitely-more film-making. Bay, however, might just be a more self-aware film-maker than most critics assume. Taken straight, the car chase in *The Rock* is nothing if not ludicrous, but taken as parody of the car chase's stale conventions, it's nothing less than hilarious – and quite possibly brilliant too. ✤

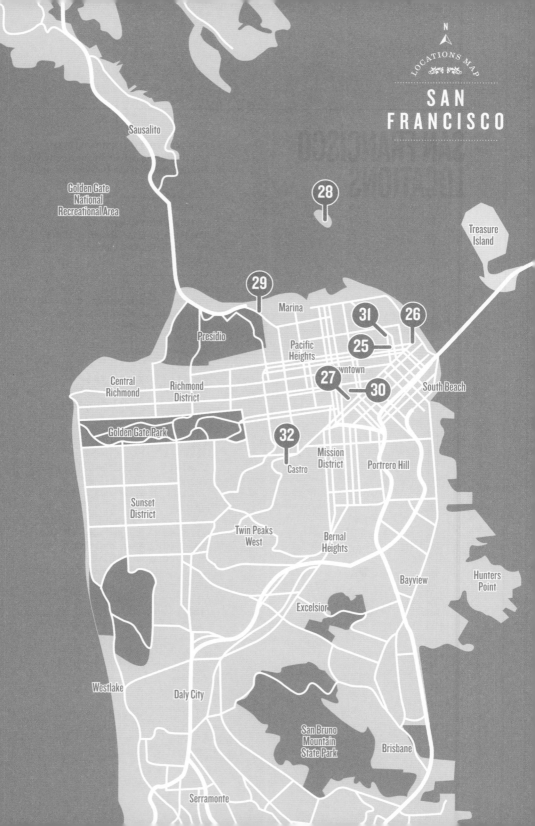

Sausalito

Golden Gate National Recreational Area

Treasure Island

28

29

Marina

Presidio

31

26

25

Pacific Heights

wntown

Central Richmond

Richmond District

27

30

South Beach

Golden Gate Park

32

Castro

Mission District

Portrero Hill

Sunset District

Twin Peaks West

Bernal Heights

Bayview

Hunters Point

Excelsior

Westlake

Daly City

San Bruno Mountain State Park

Brisbane

Serramonte

SAN FRANCISCO LOCATIONS

SCENES 25-32

25.
THE TOWERING INFERNO (1974)
555 California Street, formerly the World
Headquarters of the Bank of America
page 72

26.
HIGH ANXIETY (1977)
The lobby of Hyatt Regency Hotel,
Five Embracadero Center
page 74

27.
INVASION OF THE BODYSNATCHERS (1978)
Department of Health, 101 Grove Street
at Polk Street, opposite City Hall
page 76

28.
ESCAPE FROM ALCATRAZ (1979)
Interior of Alcatraz Federal Penitentiary,
Alcatraz Island, San Francisco Bay
page 78

29.
TIME AFTER TIME (1979)
The Palace of Fine Arts, Lyon Street
page 80

30.
RAIDERS OF THE LOST ARK (1981)
The Grand Staircase, now officially
The Charlotte Maillard Shultz Stairs,
San Francisco City Hall,
1 Dr. Carlton B. Goodlett Place
page 82

31.
CHAN IS MISSING (1982)
Outside the Hotel St Paul
(now the Hotel North Beach),
935 Kearney Street, Chinatown
page 84

32.
THE TIMES OF HARVEY MILK (1984)
The Castro District, Eureka Valley
page 86

maps are only to be taken as approximates

THE TOWERING INFERNO (1974)

LOCATION *555 California Street, formerly the World Headquarters of the Bank of America*

IN 1974, THE BUILDING THAT HOUSED the World Headquarters of the Bank of America on San Francisco's California Street was only five years old. It was tall, pristine and imposing – and perfect to serve as the entrance to 'The Glass Tower', the fictional skyscraper that would become the titular towering inferno in Irwin Allen's star-laden disaster movie. This early scene allows us to get to know two of the film's main characters, Fred Astaire's Harlee Claiborne and The Glass Tower itself. A yellow cab pulls up, and a wealthy and well-dressed man gets out. We spot that he is played by Fred Astaire. He asks the cab driver if he has change for a $50 bill and, receiving a shake of the head, counts out the 95 cent fare in small change. 'Catch your tip next time,' he says apologetically, before striding up the steps to the tower. Up close, the sight of it stuns him. He removes his glasses and stares upwards unbelievingly as we cut to a matte image of the soaring skyscraper. The Bank of America building couldn't portray the whole Glass Tower: the former is only 52 storeys high, the latter supposedly 138. The building no longer houses the Bank of America's headquarters – they moved to North Carolina in 1998 – but it is still as imposing as it ever was. Its name, however, is not. It is now known simply by its address: 555 California Street, far too modest a moniker for San Francisco's second-tallest building. ➨*Scott Jordan Harris*

Directed by John Guillermin with Irwin Allen
Scene description: The calm before the inferno
Timecode for scene: 0:09:18 – 0:10:30

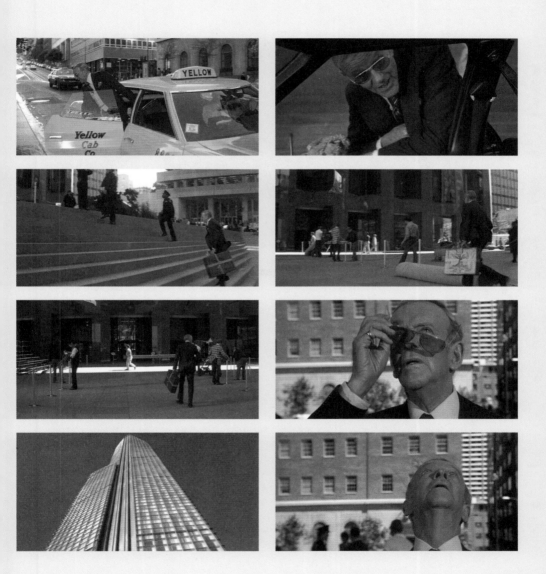

HIGH ANXIETY (1977)

LOCATION *The lobby of Hyatt Regency Hotel, Five Embracadero Center*

THOUGH MUCH OF MEL BROOKS'S AFFECTIONATE hit-and-miss send-up of Alfred Hitchcock's oeuvre was shot in and around San Francisco – glimpsed most obviously in the scenes at Fort Point, in tribute to *Vertigo* (1958) – it's undoubtedly the sequences in the Embracadero's Hyatt Regency Hotel that linger most in the memory. After all, it was here that the veteran comedian chose to stage all the film's most outlandish parodies. For instance, a hotel suite bathroom gives rise to an inevitable riff on the shower scene from *Psycho* (1960), with an enraged bellboy armed with rolled up newspaper standing in for Norman Bates and his knife (with ink, and not blood, running down the plughole). One of the Financial District's most sumptuous hotels, the building's impressive atrium and distinctive pill-shaped elevators were earlier featured in *The Towering Inferno* (John Guillerman with Irwin Allen, 1974) and Brooks playfully mocks his protagonist's terror at having to stay on one of the upper floors – following a convenient reservation mix-up caused, appropriately enough, by an unseen Mr MacGuffin. As the height-fearing Dr Richard Thorndyke – a play on the name Roger Thornhill, Cary Grant's character in *North By Northwest* (1959) – it's when staying near the summit of the Hyatt that Brooks's character suffers most from the psychological malady of the title, to typically comic effect. Yet the versatile, open space of the lobby is also wittily used to stage a recreation of the UN murder scene from *North By Northwest*, while its vastness also enables a spot of *Rear Window* (1954) style voyeurism. •►**Robert Beames**

Directed by Mel Brooks
Scene description: Spoofing 'Psycho' at the Hyatt Regency Hotel
Timecode for scene: 0:39:19 – 0:45:54

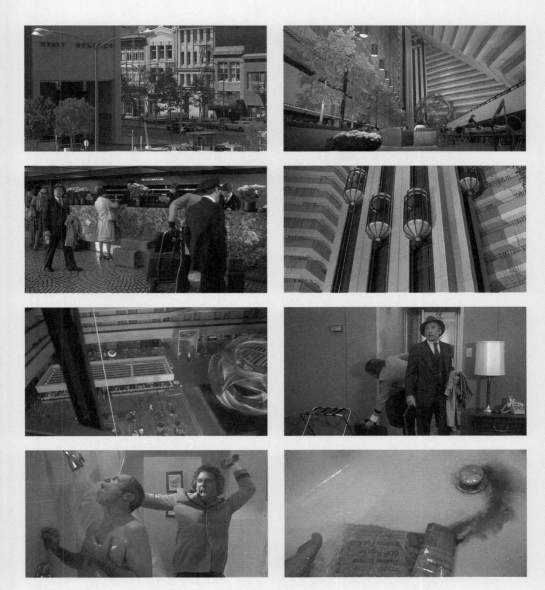

INVASION OF THE BODYSNATCHERS (1978)

LOCATION *Department of Health, 101 Grove Street at Polk Street, opposite City Hall*

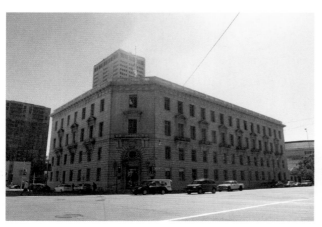

THERE IS A NEAT SUBVERSION in the use of free-wheeling San Francisco as the setting of Philip Kaufman's masterly remake of Don Siegel's paranoid sci-fi classic, given that the ultimate terror of the story is assimilation to a bland conformity that tolerates no difference: this centre of American counterculture had played out its influence of the late 1960s and early 1970s. The film presents us with a claustrophobic view of the city, which in other films is often shown in sweeping elevated vistas and bright sunshine. Here we are repeatedly given cramped interior shots. Much of the exterior action is at street level, with characters viewed through shop-windows and reflected in car windscreens. The sense of life lived on these streets is very real. The Department of Health building is an unremarkable structure, in which public servants strive to protect the citizens from threats to their well-being. Brooke Adams's Elizabeth Driscoll seems initially at ease in the polished corridors though there are unnerving occurrences early enough: a man stares through a frosted glass door and another wordlessly bumps into her. There is a solidity and sterility to contrast with the scenes of more visceral horror in one of the other main locations, the mud-bath run by Jeff Goldblum and Veronica Cartwright's characters. There, the mysterious organic terror hinted at in early shots during the opening is realized, whereas the medical centre interior allows for a creeping paranoia to be established at the heart of the city's civic establishment. •➔ *David Bates*

Directed by Philip Kaufman
Scene description: Elizabeth Driscoll goes to work
Timecode for scene: 0:13:57 – 0:15:34

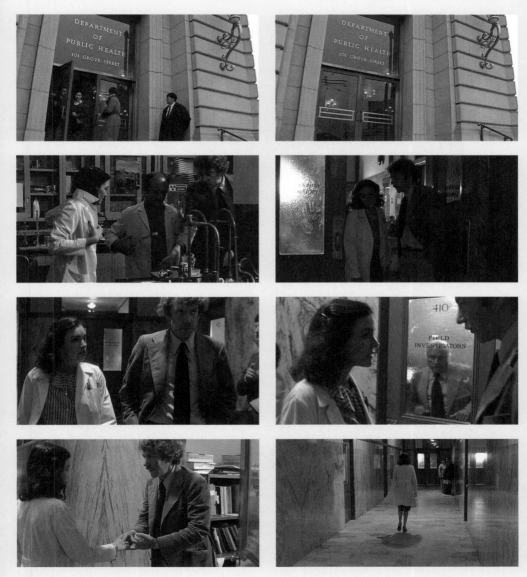

ESCAPE FROM ALCATRAZ (1979)

LOCATION *Interior of Alcatraz Federal Penitentiary, Alcatraz Island, San Francisco Bay*

A FILM THAT BILLS ITSELF as a thrilling escape from a notorious prison might be forgiven for cursorily establishing time and place before speeding to the good stuff. But a clever director knows Alcatraz needs to be the most imposing character of the piece. If we don't want to escape its tyranny, watching others do it will merely be a clinical exercise. Don Siegel is a canny director, and he doesn't rush a moment, not even the arrival of Frank Morris (Clint Eastwood) on Alcatraz. It's an arduous sequence, hammering us with the elements and with obsessive discipline. There are no sounds but buzzers, brusque orders and the clang of locks, and their repetition is skin-crawling. We never get a sense of who Morris is. He never speaks. He barely reacts. There are no flashbacks to happy days, the crime that put him there or the passing of his sentence. He's just a body – albeit a rather distinctive one in the form of Clint Eastwood – being moved from point to point, quickly stripped of humanity and dignity until he's naked and diminished. Instead it's Alcatraz that introduces itself, and as Morris moves onward, we're swallowed up. Each door leads him deeper. Each checkpoint grows more complicated. The sounds of the outside grow fainter. The clank of metal grows louder and echoes longer. Alcatraz becomes physical, a place of stale oppression we can smell, feel and taste. Escape is no longer a thrill we bought a ticket for. It's an imperative. ◆*Elisabeth Rappe*

Directed by Don Siegel
Scene description: Frank Morris arrives at Alcatraz
Timecode for scene: 0:04:20 – 0:07:24

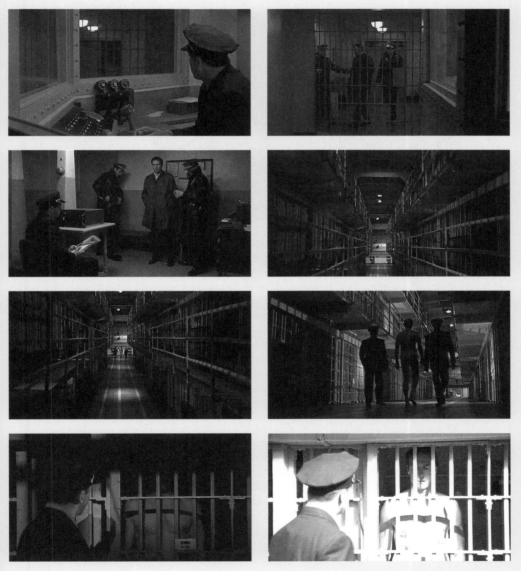

TIME AFTER TIME (1979)

LOCATION *The Palace of Fine Arts, Lyon Street*

BESIDES FOG, 1890S LONDON AND 1970S SAN FRANCISCO did not have much in common but, in Nicholas Meyer's *Time After Time*, they share two famous residents: H. G. Wells (Malcolm McDowell) and Jack the Ripper (David Warner). When the Ripper steals the time machine that Wells has not only written about but also actually built, Wells has little option but to pursue him across the years, and across the Atlantic, to the San Francisco of 1979. *Time After Time* is not, by most normal measures, a great film; judged solely by how well it shows off recognizable San Francisco locations, however, it is one of the best films ever made. Indeed, some scenes seem to exist more to celebrate the San Franciscan scenery than to tell the film's story. The most memorable of these comes when Wells takes a tour of the Palace of Fine Arts. Believing the Ripper has been killed in a car accident, Wells feels free to spend a leisurely afternoon with his newly acquired love interest, Amy Robbins (Mary Steenburgen). She offers to show him around the city, saying 'We San Franciscans are pretty proud of this old town'. As they pass the Palace of Fine Arts, Wells stops and gapes. 'What is that?' he asks in amazement. 'Isn't it incredible?' says Amy. 'They built it for the Pan-American Exposition of 1914.' 'Is it marble?' asks H. G. 'Would you believe [it's] plaster?' answers Amy, who speaks for many San Franciscans when she says, 'I love living next to it.'
➼Scott Jordan Harris

Directed by Nicholas Meyer
Scene description: H. G. Wells tours the Palace of Fine Arts
Timecode for scene: 0:57:28 – 0:58:17

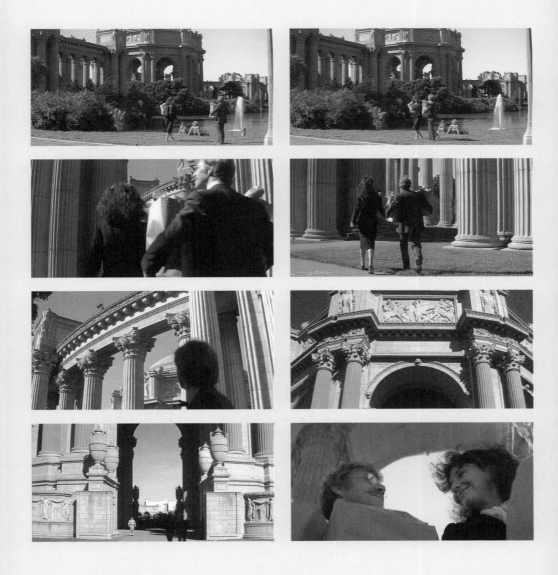

RAIDERS OF THE LOST ARK (1981)

The Grand Staircase, now officially The Charlotte Maillard Shultz Stairs, San Francisco City Hall, 1 Dr. Carlton B. Goodlett Place

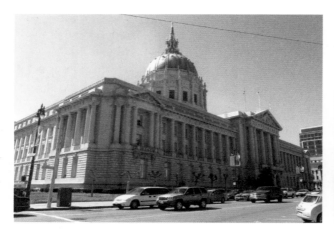

BY THE TIME SAN FRANCISCO CITY HALL makes an appearance in *Raiders of the Lost Ark*, the adventures of Indiana Jones (Harrison Ford) and Marion Ravenwood (Karen Allen) are almost over. And, when it does appear, the building is supposed to be in Washington DC: its magnificent Grand Staircase stands in for that of an unnamed government building. Having handed the Ark of the Covenant over to the authorities, Jones, still sporting his battered adventurer's hat despite wearing a suit and tie, walks forlornly from an unsatisfactory meeting with officials, knowing they will simply ignore the Ark. 'Bureaucratic fools! … They don't know what they've got there,' says Indy. 'Well, I know what I've got here,' says Marion flirtatiously. Jones sulks for a while but soon sheepishly extends his elbow towards her, and the couple descend the stairs arm in arm. Work began on the present San Francisco City Hall in 1908 after the original was destroyed by the 1906 earthquake. The breathtaking Beaux Arts building was completed in 1915 and, in the century since, has remained both the city's administrative headquarters and one of its most unmistakable sights. The 45 steps of the staircase, carved from compact limestone, are a popular spot for wedding photos: according to the *New York Times* there are 'up to six weddings an hour near the stairs' ('The Grand Staircase, City Hall' by Louise Rafkin, August 20 2011). Famous as they are, Indy and Marion are not the best-known couple to have left City Hall in each others' arms: Marilyn Monroe and Joe DiMaggio married there in 1954.
⇔Scott Jordan Harris

Directed by Steven Spielberg
Scene description: Washington DC comes to San Francisco
Timecode for scene: 1:45:22 – 1:46:04

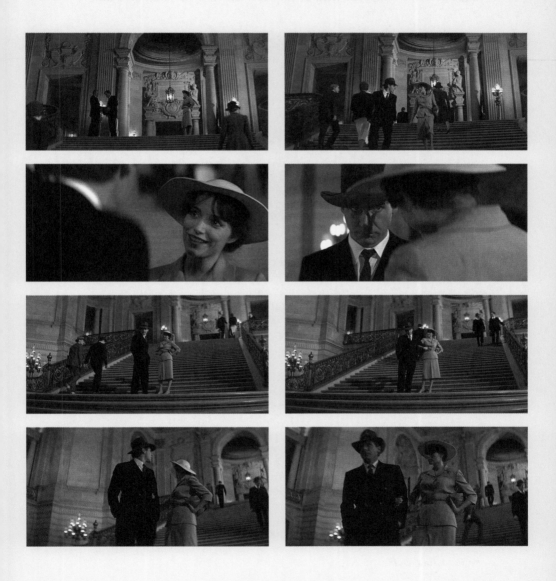

CHAN IS MISSING (1982)

LOCATION *Outside the Hotel St Paul (now the Hotel North Beach), 935 Kearney Street, Chinatown*

NOT ONLY ONE OF THE FINEST San Franciscan films but also one of the most important works in the history of Asian American cinema, *Chan is Missing* is a masterpiece of the mundane. Almost ethnographic in its attention to the details of Chinatown life, Wayne Wang's seminal movie was one of the first to show Asian Americans as they truly were, free of the racist stereotypes and comic clichés that had dominated portrayals of them in decades-worth of American movies. The film follows two taxi drivers, Jo (Woody Woy) and Steve (Marc Hayashi), as they look for the eponymous Chan, who has disappeared with $4,000 of their money. They're not really angry with him: they just wonder where he's gone. Their search takes them, and more importantly us, on a tour of Chinatown, acquainting us with its people, architecture, culture and customs. In this short, slowly paced scene, Jo and Steve take turns staking out the Hotel St Paul, where Chan lives. While they watch the hotel, we watch the sights of the town, which was famously the first Chinatown in North America and remains the largest outside Asia. Indeed, it is so large, and so densely populated, it is frequently considered a city within the city. It is unsurprisingly one of San Francisco's most popular tourist attractions but, even so, remains underrepresented on film. However, in *Chan is Missing*, there is at least one cinematic celebration of it that will endure as long as any film shot in San Francisco. **➻Scott Jordan Harris**

Directed by Wayne Wang
Scene description: Jo and Steve stake out the Hotel St Paul
Timecode for scene: 0:24:53 – 0:26:31

Images © 1982 New Yorker Films, Wayne Wang Productions

THE TIMES OF HARVEY MILK (1984)

The Castro District, Eureka Valley

'IN THE CASTRO,' says the unmistakable voice of Harvey Fierstein, narrator
of the Oscar-winning documentary *The Times of Harvey Milk*, 'a new type of
politics was taking shape. More and more men and women were arriving
in San Francisco every day to take up the gay life. The Castro was booming.
Each summer, Harvey Milk helped organize the Castro Street Fair, where
the neighbourhood celebrated its very existence.' There is no more narration
and no dialogue. For the rest of the scene, we just hear the thumping disco
of Sylvester's 'You Make Me Feel (Mighty Real)' (1976) and see the residents
of the Castro District dancing, kissing and revelling in the freedom their
neighbourhood allows. In a gay pride parade that started in the Castro
but moved elsewhere in the city, there would be a note of defiance in the
promotion of lesbian, gay, bisexual and transgender culture, but here that is
unnecessary. Here, there is only celebration. The Castro District, commonly
called just 'the Castro', is one of America's most famous gay neighbourhoods.
After 1967's 'Summer of Love', the area experienced an influx of gay
immigrants from other parts of the United States and rapidly became the
city's – and quite possibly the country's – capital of gay society. As it did so, its
name changed from the official 'Eureka Valley' to the unofficial 'the Castro',
after Castro Street's renowned Castro Theater. The prominent red sign
that announces that cinema's name is, like the Castro Street Fair, a fittingly
flamboyant celebration of selfhood. **◆Scott Jordan Harris**

Directed by Rob Epstein
Scene description: The Castro celebrates itself
Timecode for scene: 0:10:40 – 0:12:10

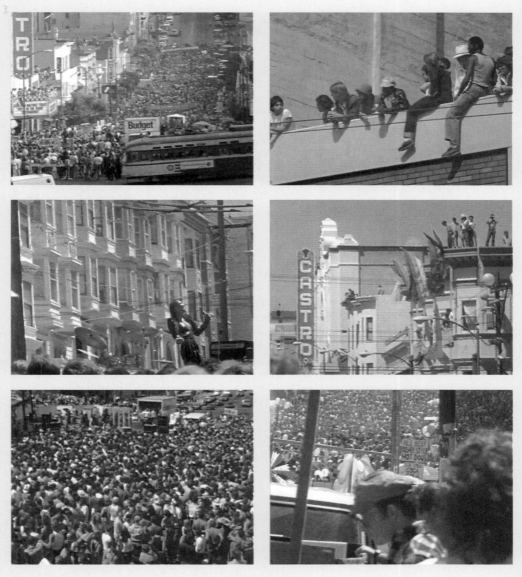

CALLAHAN'S CITY

Text by
ELIZABETH
RAPPE

Dirty Harry and the Mean Streets of San Francisco

IT'S 1971 AND A CRIME WAVE is sweeping across America. Cities seem over-run by drugs, sex, violence and all its sordid combinations. The rights of prisoners (as dictated by the newly enshrined Miranda rights) versus those of their victims is an incendiary issue. People feel unsafe. They huddle behind barred windows hoping that if anything bad happens they will have a real cop on the case. Into this murky decade strides an angry and miserable knight, brandishing the broadsword of the twentieth century – a .44 Magnum – who lets neither a hotdog nor a direct order from the mayor stand in his way.

In the eyes of pop culture mythology (the modern religion if there ever was one), Clint Eastwood's Police Inspector Harry Callahan was all that stood between us and chaos. That he belonged heart and soul to San Francisco, a Potrero Hill boy to the last, didn't matter to the myth. In the *Dirty Harry* series (Don Siegel, et al., 1971–88), San Francisco becomes a stand-in for every city, a hellish and battered symbol of America's mid-century slump.

Callahan was originally supposed to be a New York cop. The location was changed because

director Don Siegel wanted to avoid similarities with his previous Eastwood-as-rogue-cop feature, *Coogan's Bluff* (1968), and because the director and star were fond of the city. (Eastwood is every bit as much a Northern California fixture as the Golden Gate Bridge.) There's still a New York feel to the original *Dirty Harry*, particularly in Callahan's night-time patrols through city streets and alleyways, his grimace lit by neon, malice and temptation. It's not a San Francisco we've seen before (deliberately so, as Siegel sought locations that hadn't been overused) nor is it one we ever truly see again.

Subsequent installments in the *Dirty Harry* series, notably *Magnum Force* (Ted Post, 1973), *The Enforcer* (James Fargo, 1976) and *The Dead Pool* (Buddy Van Horn, 1988), found Harry stalking thugs and killers around landmarks such as the Embarcadero, the Oakland Bay Bridge, Alcatraz, Fisherman's Wharf and Chinatown, as San Francisco, which often took a backseat to Harry's dogged pursuit of Scorpio (Andy Robinson) in the original film, quickly reasserted itself as a character in the franchise, penning Callahan into the costal city limits. It's as though the city wanted to remind us who her solemn son belonged to.

But it's not as though we could have ever forgotten. There may be a New York flavour to *Dirty Harry* but there's no other city besides San Francisco that Callahan could have worked. Not only were the Zodiac Killer and the Occupation of Alcatraz fresh in people's minds (these local events were eagerly, and perhaps tastelessly, reworked into cases only Harry could handle) but also the radical turmoil of the city was a perfect backdrop to this reactionary cop.

San Francisco was where Flower Power bloomed and rotted, leaving behind the desperate and violent detritus that Harry coped with daily. It's this tidal zeitgeist that gives the *Dirty Harry* franchise such a punch, as the last gasp of the summer of 1969 is there in the background, just

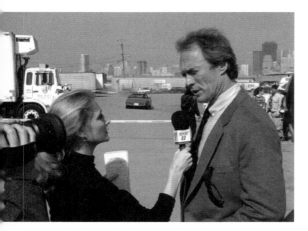

waiting for Harry to turn his steely gaze on it. It's surprising that it takes until *The Enforcer* for the two opposing forces to butt heads but, in keeping with the ironic bad luck of the character, when they do Harry is forced to confront both militants and a female partner.

The Enforcer, sitting in the middle of the franchise, actually makes for a striking parallel between the rise and fall of Haight-Ashbury and of Callahan's police career. He would have been a young cop as the Beat poets began occupying the city, and was probably filled with a similar zeal of optimism and passion (though he likely never identified with hippies or poets) before degenerating into a stalemate of bitterness, anger and frustration. (In the seventeen years we spend with Harry, he's never once up for a promotion and nor does he seek one.)

But the 1960s did enact positive change, and in handing Callahan a female partner (one who even gives him an introductory course in phallocentrism), San Francisco forces him to realize and respect that it's a new city. The next film, *Sudden Impact* (Clint Eastwood, 1983), even tests this new enlightenment by sending him to San Paulo, and nudging him into a relationship with a rape victim with a thirst for vengeance. Harry, always the wild card, sympathizes with her.

Sudden Impact also marks a change in the ever-rocky

> **Alone is something that Harry Callahan very much is. Through five films, representing countless homicide cases, San Francisco is all Callahan has.**

relationship between Callahan and his city. *Dirty Harry*, *Magnum Force* and *The Enforcer* all feature Harry being called to account for his reckless tactics and bad publicity, but in *Impact* the San Francisco Police Department finally acknowledges his success rate before sending him out of town. By *The Dead Pool*, Callahan finds himself in the awkward position of actually being a celebrity; a reporter even wants to devote a story to Callahan and his impressive career. His reputation has been rehabilitated by longevity and by changing social mores that now see a cop like Callahan as an ally, not a threat. But Harry – who must have once craved something like this – balks at the publicity and acceptance. He just wants to be left alone.

Alone is something that Harry Callahan very much is. Through five films, representing countless homicide cases, San Francisco is all Callahan has. He never gets over the cruel loss of his wife, and he replaces her with a numb devotion to the city streets. It's not just that he has nothing else but policing to do – a fact Callahan admits often – but that he's truly bound to the city that alternately loves and loathes him.

If one image sums up Callahan and his San Francisco, it's the final act of *Dirty Harry* when he surveys the Bay, jaw and throat visibly clenched as he watches Scorpio's teenaged victim pulled from the ground. San Francisco is all Callahan's battered soul has and he, scanning its hillsides, inscrutable under his Ray-Ban sunglasses, is all there is keeping it from the abyss. We may have imagined he was patrolling for all of us, but Harry would have retorted that a man's got to know his limitations, and the borders of San Francisco were his. ✠

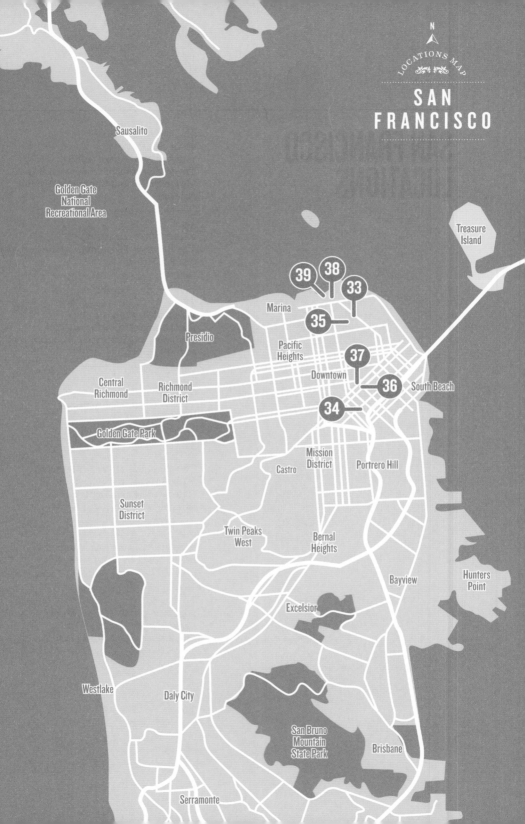

Sausalito

Golden Gate
National
Recreational
Area

Treasure
Island

Presidio

Marina

Pacific
Heights

Central
Richmond

Richmond
District

Downtown

South Beach

Golden Gate Park

Castro

Mission
District

Portrero Hill

Sunset
District

Twin Peaks
West

Bernal
Heights

Bayview

Hunters
Point

Excelsior

Westlake

Daly City

San Bruno
Mountain
State Park

Brisbane

Serramonte

39 38 33 35 37 36 34

SAN FRANCISCO LOCATIONS

SCENES 33-39

33.
STAR TREK IV:
THE VOYAGE HOME (1986)
The intersection of Greenwich Street,
Mason Street and Columbus Avenue
page 92

34.
BASIC INSTINCT (1992)
The Rawhide II country and western bar,
280 7th Street
page 94

35.
MRS DOUBTFIRE (1993)
City College of San Francisco's
Chinatown Campus, 940 Filbert Street
page 96

36.
CRUMB (1994)
Winsor Hotel, 20 6th Street
page 98

37.
INTERVIEW WITH THE VAMPIRE (1994)
The (fictional) 'Hotel St Mark' on
Market Street at the corner of Golden
Gate Avenue and Taylor Street
page 100

38.
WHEN A MAN LOVES A WOMAN (1994)
Buena Vista Café, 2765 Hyde Street
page 102

39.
MURDER IN THE FIRST (1995)
Aquatic Park Historic District,
San Francisco Maritime National
Historical Park, Fisherman's Wharf
page 104

maps are only to be taken as approximates

STAR TREK IV: THE VOYAGE HOME (1986)

LOCATION *The intersection of Greenwich Street, Mason Street and Columbus Avenue*

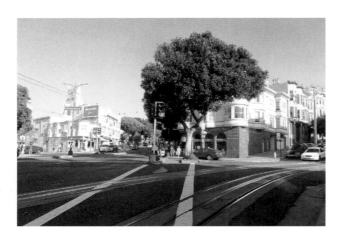

IF CAPTAIN KIRK (WILLIAM SHATNER) had landed on Earth twenty years later, he could just have done an Internet search to quickly locate all he needed to save the future Earth from its own ecological short-sightedness. But in 1986 his intrepid crew must split into teams and schlep on foot around the streets, looking for whales, a tank to hold them, and nuclear power to fly them back. What we always loved about *Star Trek* was its ability to take us out of our dull world. Though the future home of Starfleet Command, San Francisco is here merely picturesque and straight. Captain Kirk and his comrades may be middle aged and slower on their feet, but the grand endeavour of their mission – to save the Earth itself from annihilation – is dangerous and wildly daring. Chekov (Walter Koenig) and Uhura (Nichelle Nichols) stride through the streets like lost drag queens of the night in strange boots, big hair and dramatic eye make-up, blinking confusedly in the light of day. Asking for directions to the 'nuclear wessels' at the Alameda Naval base, they are met with blank stares from ignorant passers-by. Even the Village People-referencing motorcycle cop doesn't get it. Though played for comic effect, there is something quite poignant, even postmodern, about the sight of these 1960s icons. Once they opened up our imaginations and horizons with the camp, hyper-artificial rich monochrome of their fake planet sets. Here, though, on the big screen, they find themselves trapped in the bland sunlight of our own small lives. **↔Samira Ahmed**

Directed by Leonard Nimoy
Scene description: Uhura and Chekov ask directions in twentieth-century San Francisco
Timecode for scene: 0:38:50 – 0:39:55

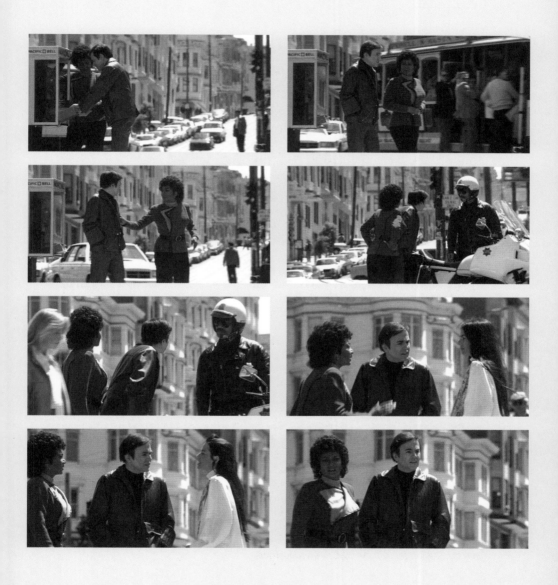

Images © 1986 Paramount Pictures, Industrial Light and Magic

BASIC INSTINCT (1992)

> *The Rawhide II country and western bar, 280 7th Street*

FOR THE MOST PART, *Basic Instinct* is set in a deluxe, neon-modern version of San Francisco. The suits and the haircuts are sharp, the buildings are glassy and spacious, and the people – particularly the women – are icily beautiful. But then, from nowhere, we come across a scene that might as well be set on a different planet. It takes place in a country and western bar, where the customers all wear cowboy hats and dance in neat pairs with one another. It's an island of Old America sticking out from the New. So, why are we here? In many other films it might be to guffaw at the old-timers in their check-shirts, but in *Basic Instinct* it feels like something different. This, after all, is the haunt of one of the film's most likeable characters, Gus Moran (George Dzundza), a homicide cop. And this is where his partner, the film's protagonist Nick Curran (Michael Douglas), reveals that he's slept with that most fatal of femme fatales, Catherine Tramell (Sharon Stone). Gus's response to the news is not only blunt but also understandable: 'Goddamn you, you are one dumb son of a bitch.' Old America may be behind the times but it's called this one right. And yet this scene was controversial when it was filmed. The location, the Rawhide II bar, was a popular gay venue at the time, and came under attack from activists angered at how *Basic Instinct* portrays various lesbian characters. As it happens, it closed in 2008, replaced by another club that has also since shut down. New and old, that's how it's always been. **⟶Peter Hoskin**

Directed by Paul Verhoeven
Scene description: 'You are one dumb son of a bitch.'
Timecode for scene: 1:20:37 – 1:21:48

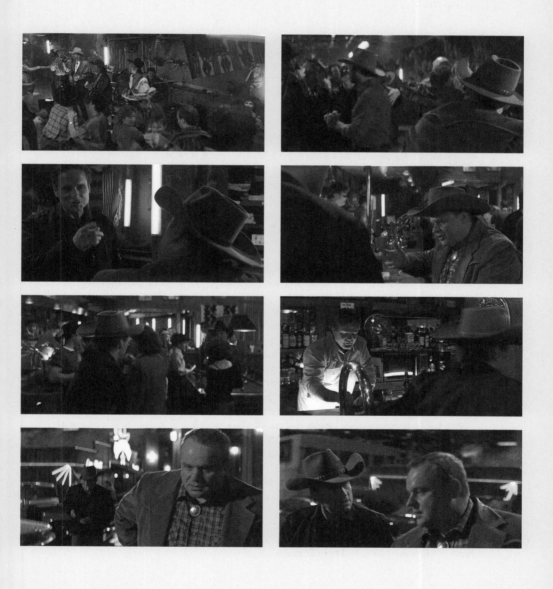

MRS DOUBTFIRE (1993)

LOCATION *City College of San Francisco's Chinatown Campus, 940 Filbert Street*

ROBIN WILLIAMS STARS in Chris Columbus's heart-warming family comedy *Mrs Doubtfire* as goofy dad Daniel Hillard. His caring, fun, yet somewhat careless personality and style of parenting is neatly set up as we see him quit a voice acting job on impulse. Before giving us a chance to dwell on this, however, he redeems himself by rushing over to his children's school on Filbert Street to pick them up in good time to arrange an impromptu birthday party for 12-year-old Chris before their mother, Miranda (Sally Field), returns home. The school scene opens with a 20-second shot of Filbert Street, beginning with a wide shot of children crossing the road. The shot looks east, uphill towards a distinctive San Francisco landmark: the striking white Saints Peter and Paul Church. The hill ascends towards the Italian district of North Beach. Telegraph Hill rises above it, with the fire hydrant-like Coit Tower perched atop its crest. The shot then pans left away from this vista to take in Daniel's car as he pulls up to the red brick school: a building that belongs to the City College of San Francisco's Chinatown and North Beach campus. Some school kids mill across the narrow sidewalk onto yellow school buses while others idle on the pavement on their bicycles discussing homework assignments. When Lydia, Chris and Natalie wander into shot a pleasing reunion takes place. Daniel's children enjoy his unexpected visit. These are our first glimpses of their seemingly idyllic middle-class lives in California's City by the Bay. •➔*Nicola Balkind*

Photos © Gabriel Solomons

Directed by Chris Columbus
Scene description: Daniel Hillard picks his children up from school
Timecode for scene: 0:03:32 – 0:05:00

CRUMB (1994)

Winsor Hotel, 20 6th Street

NO DOCUMENTARY EVER EXPOSED the psychology of its subjects as completely as *Crumb*: Terry Zwigoff's portrait of the infamously eccentric underground artist Robert Crumb and his close family is one of America's finest non-fiction films. It features several scenes shot in San Francisco and it is in one of them that we meet Maxon Crumb, Robert's younger brother, who is living in the filthy, unfurnished interior of room 310 at 6th Street's Windsor Hotel, a residence for the homeless. Maxon is a contradiction: he sits calmly in the lotus position but simultaneously seems haggard and ill at ease. Later, in this same room, we learn that he is an artist, too, and that he is also a street beggar. We see him sit on his bed of nails and hear that he has a history of publicly molesting women, a legacy, like seemingly all the Crumb brothers' behaviour, of growing up in a bizarrely dysfunctional family ruled by a hideously overbearing father. But in this scene we simply learn that Maxon was, Robert says, always 'the scapegoat of the family ... Of five children, he was definitely the bottom of the heap'. Maxon and Robert are able to laugh easily at this but we are not: there's too much sadness in the stories they tell. Since *Crumb* was shot, Maxon has continued living at Winsor Hotel but no longer begs for money or claims state benefits: instead, he makes an – admittedly meagre – income from sales of his increasingly popular paintings.
↝Scott Jordan Harris

Directed by Terry Zwigoff
Scene description: Meeting Maxon Crumb
Timecode for scene: 0:16:00 – 0:17:16

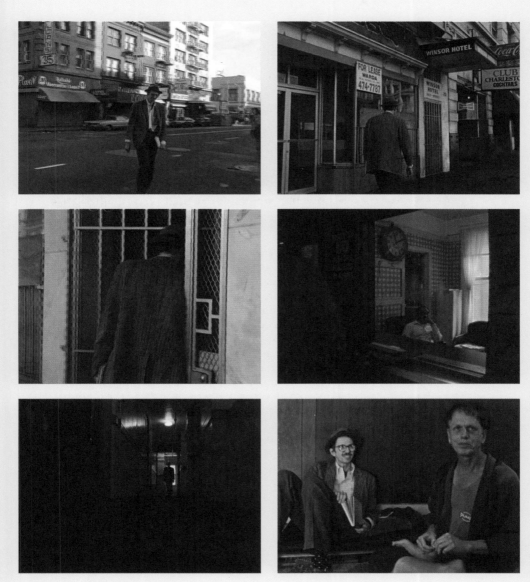

INTERVIEW WITH THE VAMPIRE (1994)

LOCATION > *The (fictional) 'Hotel St Mark' on Market Street at the corner of Golden Gate Avenue and Taylor Street*

ALTHOUGH *INTERVIEW WITH THE VAMPIRE* spans two centuries and unfolds in numerous locations – including antebellum American plantations and cities such as New Orleans and Paris – the film begins and ends in late-twentieth-century San Francisco, site of the titular interview between a 200-year-old vampire, Louis (Brad Pitt) and Daniel (Christian Slater), a radio journalist. This interview functions as the film's frame story, during which Louis tells about his life throughout several epochs, beginning with a flashback to the 1790s when he encountered the Parisian vampire Lestat (Tom Cruise), who subsequently offered Louis 'the dark gift'. Vampire Louis meets Daniel in a triangular room in the fictional Hotel St Mark, which is, in reality, a simple building in San Francisco's infamous Tenderloin district. The shabby building exterior paired with dishevelled people roaming the streets is emblematic of the Tenderloin's notorious violence and seediness. The sequence leading to the interview is set to the haunting song 'Libera Me'/ 'Deliver Me' from the Roman Catholic Requiem Mass, which is here set to music by the composer Elliot Goldentha (who later won an Oscar for *Frida* [Julie Taymor, 2002]), and sung in the original Latin by the American Boys' Choir. The ethereal, nearly angelic, quality of their voices belies the gravity of this prayer for mercy upon the soul of the deceased. This plea for salvation emphasizes how Louis, in his undead state as a vampire, suffers through his own eternal condemnation, wracked by guilt about the traumatic experiences that will always haunt him. **⚫ Marcelline Block**

Directed by Neil Jordan
Scene description: : 'What do you do?' 'I'm a vampire.'
Timecode for scene: 0:01:43 – 0:05:14

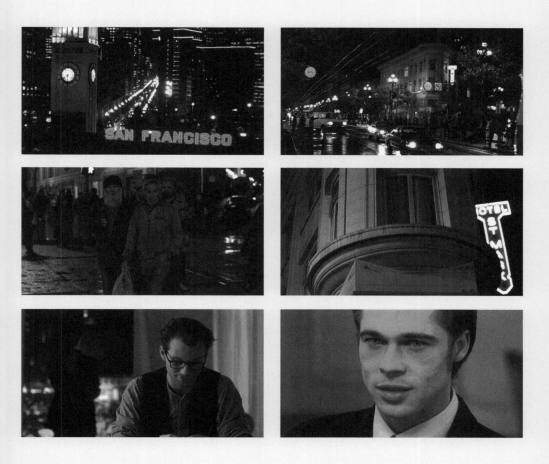

WHEN A MAN LOVES A WOMAN (1994)

LOCATION *Buena Vista Café, 2765 Hyde Street*

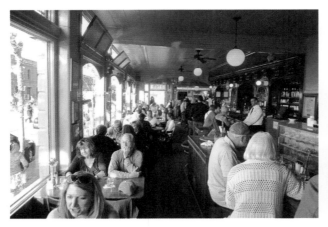

THE OPENING MOMENTS of *When a Man Loves a Woman* make sure we know it is set in San Francisco. We begin with a shot of the most iconic sight in the city, the Golden Gate Bridge, before the camera pans across a second iconic San Franciscan sight, San Francisco Bay, on its way to showing us a third: the Powell-Hyde Cable cars. It is from one of these quaint cable cars that Andy Garcia's handsome pilot steps down on his way into Hyde Street's Buena Vista Café. We lose sight of him for a while as we focus on Meg Ryan's character, sitting alone at the Buena Vista's crowded bar. A man approaches her, and tries to pick her up, but makes little progress. Suddenly, Andy Garcia's pilot moves in. Bizarrely, he asks her to collect his laundry. She seems stunned and asks what she would get in return. 'I bake,' he says, asking if she likes chocolate cake. The cafe's customers are astounded to see her climb into his lap and kiss him deeply. The couple reveal they are married, and it is clear that this man loves this woman. The Buena Vista is, as it is shown to be in the film, an incredibly popular cafe. Famous throughout the city, it is the perfect place to pick up an Irish coffee or a serving of crab cakes. It is also the perfect place to pick up a beautiful woman – particularly if she happens to already be your wife. **↠Scott Jordan Harris**

Directed by Luis Madoki
Scene description: Pick-up on Hyde Street
Timecode for scene: 0:00:13 – 0:05:00

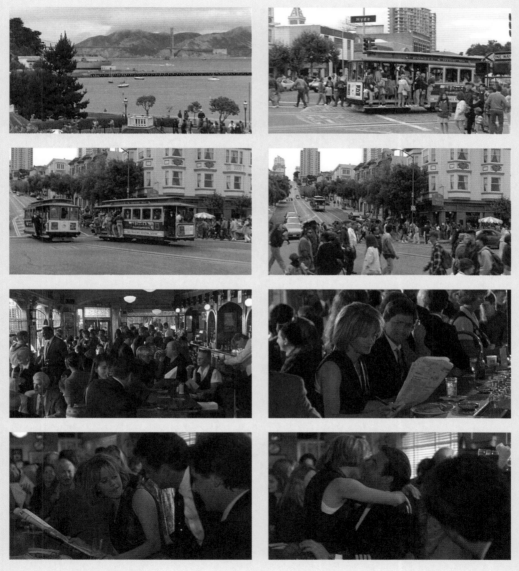

103

MURDER IN THE FIRST (1995)

LOCATION

Aquatic Park Historic District, San Francisco Maritime National Historical Park, Fisherman's Wharf

ONE OF THE BEST REASONS to visit San Francisco is to see Fisherman's Wharf and one of the best reasons to visit Fisherman's Wharf is to see the New Year's Eve fireworks. That's just what James Stamphill (Christian Slater) and Mary McCasslin (Embeth Daviditz) are doing in this scene – although there are even more fireworks between them than there are above them. The couple are ambitious young lawyers who work alongside each other and, as we watch them cutting through the crowd, we hear dialogue overlapping from the previous scene: their boss is telling McCasslin she will be replacing Stamphill on the case he is working on. As that case threatens to single-handedly bring down the brutal regime at Alcatraz, a pursuit which has become Stamphill's reason for living, he is understandably annoyed. They argue and, as dazzling ribbons of light unfurl overhead, Stamphill storms off. The scene was shot at the San Francisco Maritime National Historic Park and, more specifically, at the Aquatic Park Historic District (often called simply 'Aquatic Park') that is housed within it. Built from 1936, the park includes a beach, bathhouse and pier; is a National Historic Landmark; and is included on America's National Registry of Historic Places. The nearby Dolphin Club serves swimmers and boaters, and its members are often to be seen swimming at the Aquatic Park alongside others hardy enough to brave the chilly waters. Visitors who wish to remain warm are more likely to be found in the park's San Francisco Maritime Museum. ◆*Scott Jordan Harris*

Directed by Marc Rocco
Scene description: Fireworks at Fisherman's Wharf
Timecode for scene: 1:04:37 – 1:05:51

Images © 1995 Warner Bros. Pictures

MIDNIGHT MISSION

Text by
JASON
LeROY

Queer Culture and Midnight Movies in San Francisco

There's nothing like Midnight Mass anywhere else in the world. – John Waters

QUEER FILM CULTURE in San Francisco is as diverse and expansive as its gay population. From the historic Frameline Film Festival to the exquisitely curated Castro Theatre, and from documentaries about the tragic and triumphant history of San Franciscan gay life to emerging queer film-makers such as Travis Mathews and H. P. Mendoza, the gay community's well-documented appreciation for movies and those who make them is alive and well in the City by the Bay. But arguably its most influential member is Peaches Christ, a towering drag queen who has built a distinctly San Franciscan empire at the intersection of queer, film and underground cultures.

Peaches Christ began as Joshua Grannell, a film major at Penn State University. In 1996, his senior year, Grannell persuaded his hero and fellow Maryland native John Waters to make an appearance on campus. Waters, who has divided his time between San Francisco and his native Baltimore for many years, suggested the city to Grannell, who was unsure of his post-college plans. Waters captured his interest with stories about The Cockettes, a psychedelic 1960s drag queen troupe that performed elaborate stage shows celebrating old movies. 'He told me about San Francisco in a way I hadn't really understood it,' Grannell says. With that seed planted and rapidly growing, Grannell relocated to San Francisco after graduation.

Grannell was managing the Bridge Theatre for Landmark Theatres when he first pitched the idea for Midnight Mass: a summer program of weekend midnight movie screenings at the Bridge, each accompanied by an original drag pre-show (hosted by and starring Peaches Christ) and promoted with William Castle-style marketing. 'It was shot down pretty quickly,' Grannell recalls. 'They said midnight movies were not really an urban experience anymore. It was strictly understood as a suburban experience for teenagers who couldn't get into bars or clubs yet and, as a national theater chain, they had business results to back that up. And all I could say was, please, let me try.' Despite concerns about possibly alienating their bread-and-butter arthouse crowd 'who were paying to see *Emma* (Douglas McGrath, 1996) or whatever Merchant-Ivory film was big at the time', Landmark decided to green light Grannell's project.

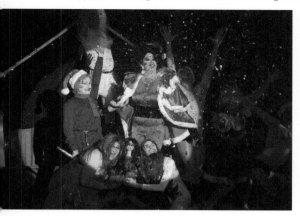

Midnight Mass officially kicked off in the summer of 1998 with Russ Meyer's *Faster, Pussycat! Kill! Kill!* (1965), paired modestly with a Tura Satana lookalike contest. The event drew 200 guests, confirming Grannell's suspicion that an audience existed for his vision. And while *Pussycat* represented the established midnight movie canon, the second week featured one of Grannell's untested midnight movie hunches: Paul Verhoeven's infamous box-office disaster *Showgirls* (1995).

'I was booking the prints through LA,' Grannell remembers. 'And that one really puzzled them. This was a movie that had just been in theaters. It wasn't old, it wasn't cult, it wasn't midnight.' But Grannell correctly sensed its cult potential. And, of course, he had a marketing ploy. 'It was PEACHES CHRIST – *SHOWGIRLS* – FREE LAPDANCE WITH EVERY LARGE POPCORN. And that's what put butts in seats.' *Showgirls* became one of Midnight Mass's most popular signature programs, with annual screenings for fifteen years and counting. Grannell has been credited with putting it on the map as a midnight movie. This also symbolized the beginning of a major shift in how midnight films were booked nationwide, leading to what Grannell calls 'the nostalgia film'.

'When we started, the standard fare was older prints like *Faster, Pussycat!* And *The Rocky Horror Picture Show* (Jim Sharman, 1975),' he says. 'So the first time we were looking for new ideas and we booked *The Goonies* [Richard Donner, 1985], everyone was like, "Why?" But I just knew as a programmer that people my age wanted to see, and celebrate, that movie on the big screen again. What the older programmers and film bookers, many of whom had been doing it for a long time, didn't realize, is that we were a generation that was raised on cable TV and VHS. So *Goonies* became a huge hit, and they began booking that kind of nostalgia programming all over the country.'

By its third and fourth seasons, Midnight Mass was selling out nearly every week. Grannell's profile continued to grow, and he eventually realized his dream of writing and directing his own campy horror film, *All About Evil* (2010). It tells the story of Deborah Tennis (Natasha Lyonne), a mousy librarian who saves her father's beloved but failing old movie house (San Francisco's Victoria Theatre, playing itself) by forming a ragtag gang of criminally insane guerilla film-makers and creating a series of stylized snuff films, gradually making her theatre the hottest destination in town. Grannell even cast two of his childhood idols whom he'd befriended through Midnight Mass: Mink Stole and Cassandra Peterson, aka Elvira. The film had an extravagant premiere at the San Francisco International Film Festival in 2010, which Grannell followed with one of the most ambitious promotional efforts in recent memory, touring the film around the country with an elaborate stage pre-show he marketed as 'The Peaches Christ Experience in 4-D'.

In a city of transplants, it is perhaps appropriate that it took two generations of pilgrims from Maryland to build what has become one of San Francisco's most popular and celebrated institutions. Taking inspiration from the city's richly countercultural history to build on and expand how midnight movies are defined around the globe, Grannell has profoundly altered the landscape of film culture in San Francisco and beyond. He echoes the quote from John Waters, his 'pope and ultimate idol,' at the top of this essay. 'Now I get flown all over the world and do this sort of stuff, and I can say, yes, there is nothing like what we do anywhere else,' he says. 'As far as the midnight movie experience, especially since drag and a transgressive spirit have always been such a big part of that, I do think San Francisco is where it's at.' ✣

In a city of transplants, it is perhaps appropriate that it took two generations of pilgrims from Maryland to build what has become one of San Francisco's most popular and celebrated institutions.

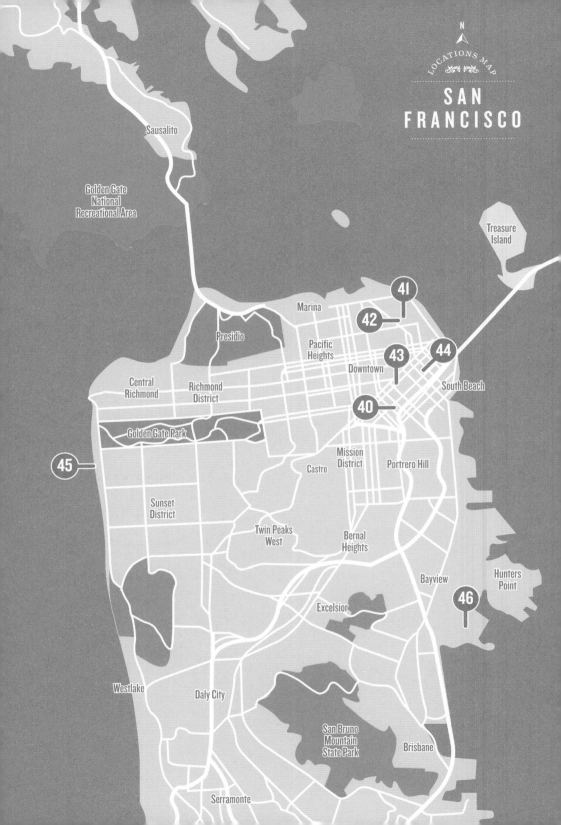

Sausalito

Golden Gate
National
Recreational
Area

Treasure
Island

Marina

Presidio

Pacific
Heights

41

42

43

Downtown

44

South Beach

Central
Richmond

Richmond
District

40

Golden Gate Park

45

Castro

Mission
District

Portrero Hill

Sunset
District

Twin Peaks
West

Bernal
Heights

Bayview

Hunters
Point

Excelsior

46

Westlake

Daly City

San Bruno
Mountain
State Park

Brisbane

Serramonte

SAN FRANCISCO LOCATIONS

SCENES 40-46

40.
JAMES AND THE GIANT PEACH (1996)
Twitching Images, AKA Skellington
Productions studio, 375 Seventh Street
page 110

41.
THE SWEETEST THING (2002)
Fresno Alley, at the intersection
with Kearny Street, North Beach/
Telegraph Hill
page 112

42.
THE WILD PARROTS
OF TELEGRAPH HILL (2005)
Telegraph Hill
page 114

43.
ZODIAC (2007)
The San Francisco Chronicle Building,
901 Mission Street
page 116

44.
MILK (2008)
Marine Fireman's Union Headquarters,
240 2nd Street
page 118

45.
REMEMBERING PLAYLAND (2010)
The Funhouse, Playland at the Beach,
next to Ocean Beach
page 120

46.
CONTAGION (2011)
Candlestick Park,
602 Jamestown Avenue
page 122

maps are only to be taken as approximates

JAMES AND THE GIANT PEACH (1996)

LOCATION *Twitching Images, AKA Skellington Productions studio, 375 Seventh Street*

BASED ON THE CLASSIC 1961 children's novel by Roald Dahl, Henry Selick's *James and the Giant Peach* is a live-action and stop-motion hybrid. The live portions of the film (its beginning and end) see James played by Paul Terry. James's parents die tragically (eaten by a rampaging rhino), leaving him in the care of his hideous Aunts Sponge (Miriam Margolyes) and Spiker (Joanna Lumley). When he's visited by an Old Man (Pete Postlethwaite) with magical secrets, a huge peach grows in his aunts' garden. As the magic takes over, James makes his way inside the peach to discover that it is home to human-sized insects. Upon his entrance, the film transforms into a distinctly Selickian stop-motion world. The animation was handled by Twitching Images, formerly known as Skellington Productions, the producers of *The Nightmare Before Christmas* (Henry Selick, 1993). Unsurprisingly, *James* is produced by *Nightmare*'s creator, Tim Burton. The Twitching Images studio stood at 375 7th Street in the central SoMA (South of Market) district of San Francisco. Perhaps fittingly, the location is now home to Bessie Charmichael Elementary School. Live scenes within the film were also shot in and around San Francisco. Early scenes depicting James on the beach with his parents were shot in an abandoned building at Hunters Point Naval Shipyard, while Building 180 on Treasure Island – the halfway point of the Bay Bridge – stood in for the aunts' home. Though its hero ventures to New York City, San Francisco is *James*'s true home. ➻*Nicola Balkind*

Directed by Henry Selick
Scene description: James's animated adventures
Timecode for scene: Location used for all animated sequences

THE SWEETEST THING (2002)

LOCATION

Fresno Alley, at the intersection with Kearny Street, North Beach/Telegraph Hill

CHRISTINA (CAMERON DIAZ) is in her late twenties and enjoys being single, with a flourishing career and great apartment in San Francisco's North Beach/Telegraph Hill, along with a social life in the fast lane. Together with her best friends, Courtney (Christina Applegate) and Jane (Selma Blair), she patronizes the city's restaurants, bars and nightclubs, engaging in casual relationships with men, unbothered by the trail of broken hearts left behind her. Christina's fear of commitment is the basis for her dating philosophy, which is challenged when she encounters Peter (Thomas Jane), sparking the realization that she does indeed crave emotional fulfilment. Courtney and Christina then impulsively crash a wedding they believe is that of Peter's brother, held in a small town far away. This misadventure leads both women to admit that they have had it with the dating scene: they are looking to find true, lasting love. Upon returning to the city, the two friends walk up the once-seedy but now-gentrified Fresno Alley – near the oldest bar in San Francisco, The Saloon – an alleyway that intersects with Kearny Street, where Christina's apartment is located. Police sirens and flashing lights greet them, but rather than heed an officer asking them to stay away, they rush inside, where Jane and her beau are entangled in a ridiculous predicament, much to the amusement and/or horror of onlookers gathered around to watch the incredible spectacle. Christina and Courtney save the day, demonstrating that, along with romantic love, friendship is the film's other main preoccupation.
↝ Marcelline Block

Directed by Richard Kumble
Scene description: 'But that's my apartment!'
Timecode for scene: 1:00:45 – 1:02:32

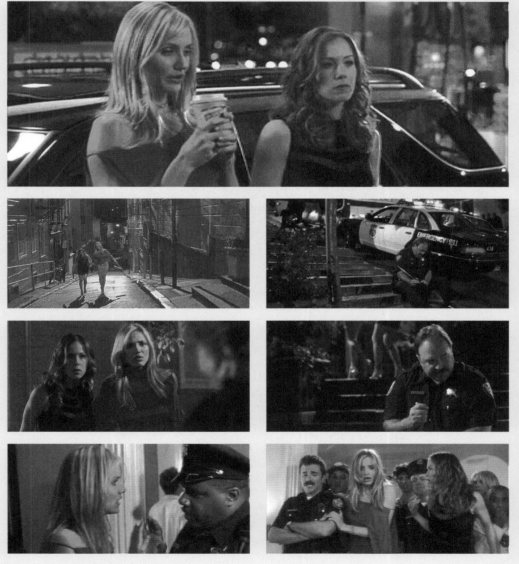

Images © 2002 Columbia Pictures Corporation, Konrad Pictures

THE WILD PARROTS OF TELEGRAPH HILL (2005)

Telegraph Hill

'IT WASN'T A PLAN: IT JUST HAPPENED. It was what I was doing while I was trying to figure out … where I was going in my life. But it became the thing that I'm doing. It's magic that way.' Mark Bittner is talking about caring for the wild parrots that inhabit Telegraph Hill but, more than that, he is talking about discovering his purpose in life. In one sense, Bittner is homeless: he admits he hasn't paid rent in 25 years. But, in another sense, he is completely at home. Indeed, no one could seem more at home than Bittner does on Telegraph Hill, talking to the parrots and talking to us about them. We watch him watch them frolic on overheard cables; at first, he says, they seemed more like monkeys than birds. Then we watch him feeding the flock, and it is easy to see how he and it became two of San Francisco's living landmarks. Telegraph Hill takes its name from a semaphore station erected on it in 1795 and is one of the original 'Seven Hills of San Francisco' on which the city was supposedly built. It is well-known for a few reasons: its stairs, its gardens and the elegant Coit Tower. But those have become secondary attractions. Thanks to the birds, to Bittner, and to Judy Irving's film, Telegraph Hill is internationally synonymous only with wild parrots. Bittner has left the hill now, but the parrots remain – and, partly because of him, they continue to thrive. **➼Scott Jordan Harris**

Directed by Judy Irving
Scene description: Bird-watching on Telegraph Hill
Timecode for scene: 0:24:00 – 0:26:02

Images © 2005 Pelican Media

ZODIAC (2007)

The San Francisco Chronicle Building, 901 Mission Street

IN ZODIAC, David Fincher's 2007 true-crime mystery thriller, the *San Francisco Chronicle*'s staff routinely gathers in a dark wood-panelled newsroom to discuss the day's potential news stories. The aim, of course, is to sell newspapers and keep everyone employed, but the *Chronicle* is a major-city newspaper, presumably serving the public good, not just private profit. On this particular day, however, the editors face a difficult dilemma. It's not whether to report the violent attacks and murders committed by an as yet unnamed killer but whether to publish the killer's letter and a cipher in the afternoon edition of the *Chronicle*. The writer threatens to kill twelve people if they go unpunished. The editors know that, by publishing, they would be giving the killer exactly what he wants – publicity for his crimes – but they might save lives too. In the end, the profit motive, mixed at least superficially with the public's right to know, wins out and a local killer becomes a national bogeyman. Editorial ethics is only one of *Zodiac*'s concerns (and a minor one at that). The film is also a trenchant study in obsession (and the destructive effects thereof) as the repeated failure of Paul Avery (Robert Downey, Jr), a *Chronicle* reporter, to uncover the Zodiac's identity transforms the *Chronicle*'s cartoonist, Robert Graysmith (Jake Gyllenhaal), into a lone, ultimately isolated crusader, practically losing everything, including his family, in the decades-long search for the killer's identity. Certainty and closure, however, ultimately prove elusive. ◆**Mel Valentin**

Directed by David Fincher
Scene description: The staff of the Chronicle discuss the first Zodiac letter
Timecode for scene: 0:08:37 – 0:14:26

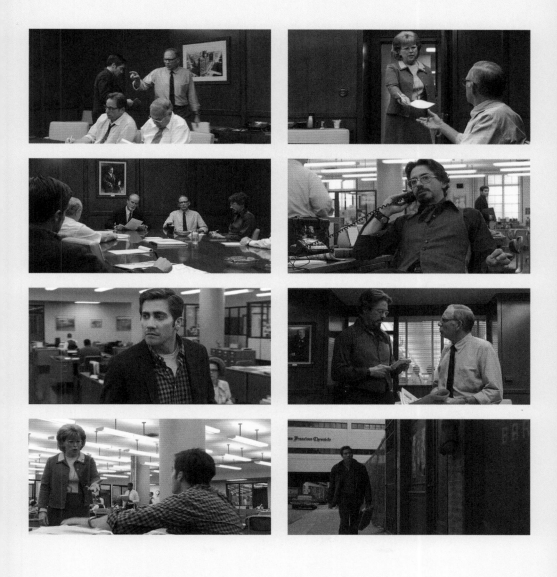

MILK (2008)

LOCATION *Marine Fireman's Union Headquarters, 240 2nd Street*

THE PIONEERING LIFE and tragic early death of 'The Mayor of Castro Street', Harvey Milk, California's first openly gay elected official, was movingly recreated in Gus Van Sant's 2008 biopic. Harvey was brought to life in an Academy Award-winning performance by Sean Penn. Brutally assassinated along with San Francisco Mayor George Moscone by unstable Democrat politician Dan White, Harvey Milk served on the San Francisco Board of City Supervisors for less than a year before his untimely death. Though his time in office was cruelly cut short, Harvey made an indelible mark on the LGBT community he represented and on the American political landscape. Filmed on location around the city, and including archive footage from the era, *Milk* features many of the actual places that Harvey frequented, from Castro Camera, his home and business in the Castro District, to the corridors of power in City Hall itself. One brief but telling sequence sees Harvey deliver a campaign speech at the city's Marine Fireman's Union Headquarters on 2nd Street. An integral part of the city's history, the union was established in 1883 and the headquarters built in 1957. Barely twenty seconds in length, the sequence nevertheless highlights both Harvey's fearless nature and the city's much-vaunted spirit of tolerance and progressiveness. Surrounded by blue-collar workers, the besuited Harvey knows he needs the union's support to help in his bid for office. His speech is greeted by warm applause, the union's support is secured and a potential barrier to Harvey's ambitions falls away.
↝ Neil Mitchell

Directed by Gus Van Sant
Scene description: Harvey gives a speech to the Marine Firemen
Timecode for scene: 0:42:45 – 0:43:05

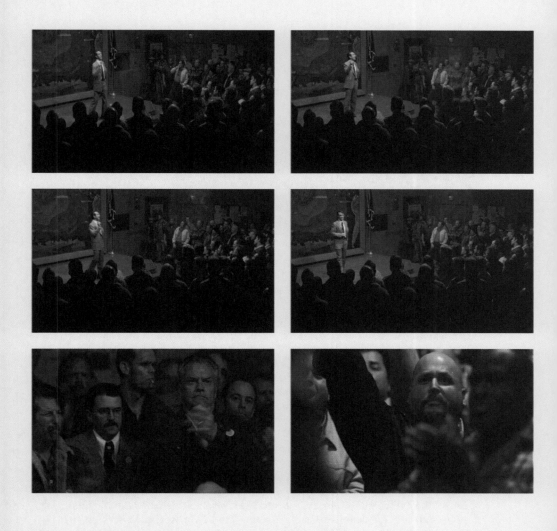

REMEMBERING PLAYLAND (2010)

The Funhouse, Playland at the Beach, next to Ocean Beach

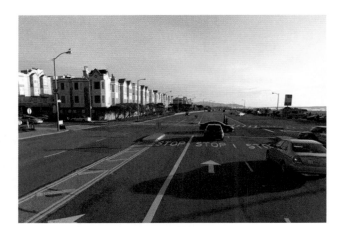

FROM 1928 UNTIL ITS DEMOLITION in 1972, Playland at the Beach – home of the Big Dipper and birthplace of the It's-It ice-cream sandwich – was the San Franciscan equivalent of Coney Island. For his documentary, *Remembering Playland*, Tom Wyrsch interviews former patrons and employees, as well as local historians, in an effort to recapture the essence of the beloved amusement park. In the film's centrepiece sequence, we are shown the heyday of the park's centrepiece attraction: the Funhouse. While other attractions charged individual fees, everything within the Funhouse was covered by the cost of admission to it, meaning that it was, one contributor says, 'an amusement park inside of an amusement park.' We see customers queuing to enter the Funhouse; we see them sitting on the spinning, polished surface of its Joy Wheel; and we watch a camera zoom down its long, undulating slide. We hear stories of birthday parties, childhood afternoons and teenage nights spent inside it. For former Funhouse customers, watching this scene must unleash an avalanche of happy memories. Even for those of us who know Playland only through this film, it almost feels as if we have been there. After Playland's closure, some of those who loved it established the Playland Not at the Beach museum on El Cerrito's San Pablo Avenue. Like this documentary, the museum exists to remind those who once went how much fun they had – and to show those who never did how much fun they missed – at Playland at the Beach.
➻ Scott Jordan Harris

Photo © Skrach (vividlyvintage.com)

Directed by Tom Wyrsch
Scene description: 'An amusement park inside of an amusement park.'
Timecode for scene: 0:12:51 – 0:19:27

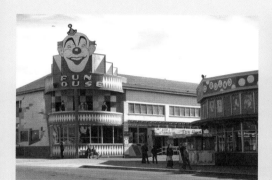

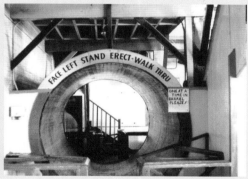

Images © 2010 November Fire Recordings

CONTAGION (2011)

Candlestick Park, 602 Jamestown Avenue

CONTAGION IS TERRIFYING, not because it contains great shocks or grotesque violence but because it presents a comprehensive illustration of the horrors that might follow the international outbreak of a lethal and rapidly communicable disease in our age of overpopulation and easy air travel. By this scene, though, our terror is subsiding: we have watched the devastation caused by the disease but we have also watched a vaccine being discovered and mass-produced. Now we are watching it being mass-administered – and, in San Francisco, there could be no better site for this than Candlestick Park. The stadium, which seats almost 70,000 spectators, holds a special place in San Franciscan culture because it has been home to the city's two most beloved sports teams: baseball's San Francisco Giants and the NFL's San Francisco 49ers. Opened in 1960, Candlestick was built for the Giants, who used it until 1999. It is still used by the 49ers, who moved in in 1971. But 'The 'Stick' is not simply a sports venue: it also hosts high-profile entertainment events. And none had a higher profile than the one it hosted on 29 August 1966: the final concert by The Beatles. There is something bitterly believable about Candlestick being used for relief efforts during a disaster. If its appearance in *Contagion* ever seems fanciful, we have only to remember the awful earthquakes that have struck San Francisco (one of which interrupted a World Series game at Candlestick) and recall the New Orleans Superdome sheltering victims of Hurricane Katrina. ⊷*Scott Jordan Harris*

Directed by Steven Soderbergh
Scene description: Vaccinating San Francisco
Timecode for scene: 1:33:51 – 1:34:19

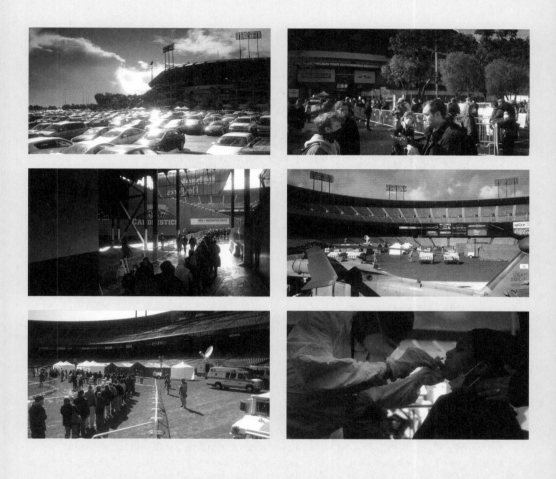

GO FURTHER

Recommended reading, useful websites and film availability

BOOKS

Celluloid San Francisco: The Film Lover's Guide to Bay Area Movie Locations
by Jim Van Buskirk and Will Shank
(Chicago Review Press, 2006)

Cinema by the Bay
by Sheerly Avni
(George Lucas Books, 2006)

**Footsteps in the Fog:
Alfred Hitchcock's San Francisco**
by Jeff Kraft and Aaron Leventhal
(Santa Monica Press, 2002)

**The San Francisco of Alfred Hitchcock's Vertigo:
Place, Pilgrimage, and Commemoration**
by Douglas A. Cunningham
(Scarecrow Press, 2011)

Vertigo: The Making of a Hitchcock Classic
by Dan Auiler (St Martin's Press, 1998)

**San Francisco Noir:
The City in Film Noir from 1940 to the Present**
by Nathaniel Rich (Little Bookroom, 2005)

**Radical Light: Alternative Film and Video in the
San Francisco Bay Area, 1945–2000**
by Steve Anker, Kathy Geritz and Steve
Seid (University of California Press, 2010)

BFI Film Classics: 'Greed'
by Jonathan Rosenbaum
(British Film Institute, 2008)

**Lonely Planet:
San Francisco Travel Guide 8th Edition**
by John Vlahides and Alison Bing
(Lonely Planet, 2012)

**San Francisco:
The City's Sights and Secrets**
by Leah Garchik (Chronicle Books, 2006)

Infinite City: A San Francisco Atlas
by Rebecca Solnit
(University of California Press, 2010)

**Alcatraz: A Definitive History of the Penitentiary
Years 8th Edition**
by Michael Esslinger
(Ocean View Publishing, 2011)

**Birdman of Alcatraz:
The Story of Robert Stroud**
by Thomas E. Gaddis
(Comstock Publishing, 1989)

FILMS

**American Experience:
The Great San Francisco Earthquake**
Rocky and Matthew Collins, dir. (PBS, 2005)

Sutro's: The Palace at Land's End
Tom Wyrsch, dir.
(November Fire Recordings, 2011)

Common Threads: Stories from the Quilt
Rob Epstein and Jeffrey Friedman, dir.
(Couterie, 1989)

Destination San Francisco
Daval Productions, prod.
(TravelVideoStore.com, 2009)

ONLINE

**Official website of the City and County
of San Francisco**
http://www.ci.sf.ca.us/index.asp

San Francisco Travel
http://www.sanfrancisco.travel/

SanFrancisco.com
http://www.sanfrancisco.com/

San Francisco Film Society
http://www.sffs.org/

San Francisco Film Commission
http://www.filmsf.org/

San Francisco Film Critics Circle (SFFCC)
http://sffcc.org/main/

San Francisco Film Locations Tours
http://www.sanfranciscomovietours.com/

The film section of the **San Francisco Chronicle**
http://www.sfgate.com/movies/

The San Francisco section of **MovieLocations.com**
http://www.movie-locations.com/places/usa/sanfran.html

Film in America's extensive list of San Francisco
films, with location information
*http://www.filminamerica.com/PacificNorthwest/
NCA/SanFrancisco/*

CONTRIBUTORS

Editor and contributing writer biographies

EDITOR

SCOTT JORDAN HARRIS is a British film critic and sportswriter. Formerly Online Arts Editor of *The Spectator* and Editor of *The Big Picture* magazine, he is now a culture blogger for the *Daily Telegraph*; a contributor to BBC Radio 4's *The Film Programme*; and Roger Ebert's UK correspondent. His work has been published by, among many others, *Sight & Sound*, *The Spectator*, *The Guardian*, BBC online, the *Chicago Sun-Times*, the *Huffington Post*, *Fangoria*, *movieScope*, Turner Classic Movies, Film4.com and The Australian Film Institute. Scott has contributed to more than a dozen books on film and is also editor of the World Film Locations volumes on New York, New Orleans and Chicago. In 2010 his blog, *A Petrified Fountain*, was named by *Running in Heels* as one of the world's 'best movie blogs'. He is on Twitter as @ScottFilmCritic.

CONTRIBUTOS

SAMIRA AHMED is an award-winning freelance journalist, columnist and broadcaster with a special interest in Westerns, comics and children's television. She presents news and cultural discussion programmes for BBC radio and television including *Night Waves*, *The Proms* and *Sunday Morning Live* and writes for newspapers including *The Guardian* and *The Independent*. She won the Stonewall Broadcaster of the Year award while a correspondent and news anchor at Channel 4 News and has worked as the BBC's Los Angeles Correspondent and for Deutsche Welle TV in Berlin. Samira is also Visiting Professor of journalism at Kingston University in London.

NICOLA BALKIND is a writer, digital freelancer and formerly California-based Glaswegian. She contributes to a number of volumes in the World Film Locations series as well as BBC Radio Scotland's *Movie Café* and regional press. You can find Nicola online at http://nicolabalkind.com and on Twitter @robotnic.

DAVID OWAIN BATES spent his childhood on a Carmarthenshire farm, has looked after children with learning disabilities in Bristol, worked as a chef in a Chinese Restaurant in West Wales, and run a pub in South London. He worked in an Internet company at the height of the dot-com boom, where he drank a lot of the venture capitalist's money in the finest bars in Soho and lost his job in the crash. He has been involved in an international charity start-up and solved more computer problems and server crashes than he can recall. One day he will decide what he wants to do when he grows up but until then is dealing with an addiction to DVD box-sets and a love of the liminal dream world of the cinema, where he mutters darkly about safety lights ruining the magic. He wants to live in the Everyman in Hampstead.

ROBERT BEAMES is a freelance film critic who has written for a number of publications and websites, including the *Daily Telegraph* and *What Culture*, in addition to keeping his own movie blog: *BeamesOnFilm*. He also occasionally appears on local radio in his native East Sussex and, from time to time, can be found hosting Q&As at Brighton's Duke of York's Picturehouse, for whom he also co-hosts a popular podcast. In recent times, he's been lucky enough to interview some of his film heroes, including Werner Herzog, Darren Aronofsky and John Lasseter. His favourite film is *Punch-Drunk Love* (Paul Thomas Anderson, 2002).

OLIVIA COLLETTE is a writer based in Montreal. She is one of Roger Ebert's Far-Flung Correspondents and has also contributed to *The Spectator Arts Blog*, the *Montreal Gazette*, *Sparksheet* and IndieWire's *Press Play*. She may have declared what her favourite movie was on some ➔

CONTRIBUTORS

Editor and contributing writer biographies (continued)

blog or during an inadvertent interview, but she reserves the right to change her mind. Because, let's face it, *Private School* didn't age as well as we all thought it would. She was born on Canada's West Coast in Victoria, British Columbia.

BRIAN DARR is a writer, cinephile and San Francisco native. In 2005 he founded a blog about the San Francisco area specialty film-screening scene, named *Hell On Frisco Bay* after a 1955 gangster picture starring Alan Ladd, Fay Wray and Edward G. Robinson and directed by Frank Tuttle. He has also contributed articles to the San Francisco Silent Film Festival, *Senses of Cinema*, *Keyframe*, *First Person Magazine* , and other outlets. In addition to his cinephilia, he creates haunted houses, performs electronic music and works in libraries. He is indebted to Eddie Muller (of the Noir Film Foundation) and Miguel Pendás (who leads movie location tours for San Francisco film festival-goers) for setting him down a path of noir obsession. That he shares a surname with Marie Windsor's character in *The Sniper* (Edward Dmytryk, 1952) is pure coincidence.

JEZ CONOLLY holds an MA in Film Studies and European Cinema from the University of the West of England, is a regular contributor to *The Big Picture* magazine and website, and has co-edited the Dublin and Reykjavík volumes in the World Film Locations series with Caroline Whelan. His book, *Beached Margin: the role and representation of the seaside resort in British films* was published in 2008. He is currently working on *World Film Locations: Liverpool* and a monograph about John Carpenter's *The Thing* (1982). In his spare time he is the Arts and Social Sciences & Law Faculty Librarian at the University of Bristol.

PETER HOSKIN's first job in journalism was as Online Editor of *The Spectator*, from January

2008 to June 2012. He is now an Associate Editor and columnist for the political website *ConservativeHome*, and co-editor of the arts website *Culture Kicks*. He continues to write about politics and culture for print outlets including *The Times*, *The Spectator* and *Tatler*.

SIMON KINNEAR (@kinnemaniac) is a freelance film journalist He is a regular reviewer and feature writer for *Total Film*, and has also written for *SFX*, *Doctor Who Magazine* and *Clothes On Film*. He introduces film screenings at Derby QUAD and writes a movie blog, www.kinnemaniac.com. In addition to this volume of the World Film Locations series, he has contributed to the New York, Glasgow and New Orleans editions.

JASON LEROY is a pop culture journalist and blogger. Hailing originally from Houston, PA, he graduated from Kent State University with a BA in English in 2005 and moved to San Francisco that same year. He launched the entertainment blog, *The Sassmouth Chronicles*, in 2008 and became the movies editor for *Spinning Platters* (http://spinningplatters.com) in 2010. A copywriter by trade, he has written for such brands as Old Navy, Gap, Docker, and The Sharper Image. He is perhaps best known as the journalist to whom Rashida Jones was speaking when she urged John Travolta to come out, leading to Jason's first awkward phone call from *Inside Edition*. He's become more comfortable around movie stars since once losing his composure and terrifying Anna Kendrick during a Golden Globes party at the Chateau Marmont in 2010, but he still hyperventilates around internet celebrities and reality stars. Find him on Twitter at @Jason_LeRoy.

MICHAEL MIRASOL is a Filipino independent blogger, film critic and video essayist who has

written about film for the past twelve years. He briefly served as film critic for the *Manila Times* and now contributes occasionally to several online publications such as the ACMI Blog, *Fandor*, IndieWire's *PressPlay*, *The Spectator Arts Blog*, and *Uno Magazine*. In 2010, he was named as one of Roger Ebert's Far-Flung Correspondents, and occasionally serves as a panellist at Roger Ebert's film festival, Ebertfest. He currently resides in Perth, Australia.

NEIL MITCHELL is a writer and editor based in Brighton, East Sussex. He edited *World Film Locations: London*, *World Film Locations: Melbourne* and co-edited *Directory of World Cinema: Britain* for Intellect. He edits *The Big Picture* magazine and writes regularly for *Electric Sheep* and *Eye For Film*. His work has appeared online for *The Guardian*, *The Spectator* and *Little White Lies*.

OMAR MOORE is a film critic and attorney. Born and raised in London, he is the editor and owner of the film website *The Popcorn Reel* (PopcornReel. com). Omar is a Far-Flung Correspondent for Roger Ebert, and has also contributed to the Public Broadcasting television program *Ebert Presents At The Movies*. Omar is the San Francisco Indie Examiner for Examiner.com and a member of the San Francisco Film Critics Circle.

CRAIG PHILLIPS is a San Francisco-based writer who has worked in film and journalism in both the Bay Area and Los Angeles for many years. He's written about film and TV for *Variety*, *GreenCine*, Movies.com, *Fandango* and *Fandor*. Craig was a script reader and development associate in Hollywood for directors Jon Avnet, Ed Zwick and Marshall Herskovitz (*My So Called Life* [1994], *Glory* [1989], *The Last Samurai* [2003]); and also worked for HBO, Miramax, Dimension and Mandeville Films. He once optioned a screenplay

to director Charles Burnett (*To Sleep With Anger* [1990], *Killer of Sheep* [1979]) that was never produced. He's taught writing to teens and adults at 826 Valencia and Fort Mason Center, studied film at San Francisco State University and holds an MFA from California College of the Arts (CCA).

ELISABETH RAPPE studied history and English literature at Metropolitan State College of Denver before abandoning academia for film. Her work has been featured on *The Spectator Arts Blog*, *Cinematical*, Film.com, MTV, *Latino Review*, and in the World Film Locations books on New York, New Orleans and Chicago. She has offered commentary on geek culture on NPR's *The Takeout*, Chicago's WGN, and numerous podcasts. As an avid, obsessive fan of Clint Eastwood, working on *World Film Locations: San Francisco* has been one of the most exciting projects she has ever tackled. She resides on the high plains of Colorado, where she spends her off-time watching, reading, writing, gaming, and chasing after Elliot the pug and Tuco the parrot.

MEL VALENTIN is a freelance writer, critic, and editor based in San Francisco, California. He has an undergraduate degree in Economics and Political Science from New York University. He also has a law degree from the same university. Mel contributes film reviews, article, and interviews to eFilmCritic.com, NextProjection.com, SFStation. com, and VeryAware.com. He's also contributed to Cinematical.com and Movie-Vault.com. He counts *The Big Lebowski* (Joel and Ethan Coen, 1998), *Singin' in the Rain* (Stanley Donen and Gene Kelly, 1952), *Vertigo* (Alfred Hitchcock, 1958), *Once Upon a Time in the West* (Sergio Leone, 1968), *High and Low* (Akira Kurosawa, 1963), *Blade Runner* (Ridley Scott, 1982) and *The Thing* (John Carpenter, 1982) among his favourite films. Ask him tomorrow, though, and more likely than not, Mel will give you a totally different answer.

FILMOGRAPHY

All films mentioned or featured in this book

All about Eve (1951)	32
American Graffiti (1973)	64
Barbary Coast, The (2002)	28
Basic Instinct (1992)	69, 94
Birdman of Alcatraz, The (1962)	42
Birds, The (1963)	46, 48, 49
Black Paradise (1926)	8
Book of Eli, The 2010)	9
Born to Kill (1947)	29
Bullit (1968)	5, 54, 68
Caine Mutiny, The (1954)	34
Chan is Missing (1947)	29, 84
Contagion (2011)	122
Conversation, The (1974)	7, 29, 66
Coogan's Bluff (1968)	88
Core, The (2003)	9
Crumb (1994)	98
D.O.A. (1950)	29
Dark Passage (1947)	8, 22, 29
Days of Wine and Roses (1962)	44
Dead Pool (1988)	69, 88
Dirty Harry (1971)	5, 7, 56, 68, 88
Earthquake 10.5 (2004)	9
End, The (1953)	29
Enforcer, The (1976)	88
Escape from Alcatraz (1979)	7, 78
Fallen Angel (1945)	28
French Connection, The (1971)	68
Game, The (1997)	7
Graduate, The (1967)	52
Greed (1924)	18
Guess Who's Coming to Dinner (1967)	6
Harold and Marde (1971)	58
Herbie Rides Again (1974)	8
High Anxiety (1977)	9, 74
Impact (1949)	29
Interview with the Vampire (1994)	100
Invasion of the Body Snatchers (1978)	76
It Came From Beneath the Sea (1955)	9, 36
Jade (1995)	69
James and the Giant Peach (1996)	110
Killer Elite, The (1975)	69
Lady of Shanghai, The (1947)	26, 29
Launch of Japanese man-of-war 'Chitosa' (1898)	12
Lineup, The (1958)	9, 26, 29
Magnum Force (1973)	88
Maltese Falcon, The (1941)	5, 20, 28
Man who cheated himself, The (1950)	29
Medicine for Melancholy (2009)	7
Mega- Shark vs Giant Octopus (2009)	9
Midnight Mass (2010)	106
Milk (2008)	8, 118
Mrs Doubtfire (1993)	96
Murder in the First (1995)	104
My Favourite Brunette (1947)	24
Navigator, The (1924)	16
On the Beach (1959)	9
Out of the Past (aka My Gallows High) (1947)	28
Pal Joey (1957)	38
Petulia (1968)	8
Play it again, Sam (1972)	60
Presido, The (1988)	69
Raiders of the Lost Arch (1982)	82
Raw Deal (1948)	8
Rebecca (1940)	48
Remembering Playground (2010)	120
Rise of the Planet of the Apes, The (2011)	9
Rock, The (1996)	7, 69
Sally Gardner at a Gallop (1878)	28
San Francisco: Aftermath of an Earthquake (1906)	5, 14
San Francisco (1936)	6
Shadow of a Doubt, A (1943)	48
Shakedown (1950)	29
Sniper, The (1952)	29
So I married an Axe Murderer (1993)	8
Star Trek IV: The Voyage Home (1986)	92
Sudden Fear (1952)	29
Sudden Impact (1983)	89
Superman (1978)	9
Sweetest Thing, The (2002)	112
Thieves Highway (1949)	29
Time after Time (1979)	5, 80
Times of Harvey Milk, The (1984)	86
Towering Inferno, The (1972)	72, 74
Vertigo (1958)	5, 6, 9, 29, 40, 48, 74
Vertigo (1958)	6, 29, 48
View To A Kill, A (2006)	9
What's up Doc? (1972)	62, 68
When a man loves a woman (1994)	102
Wild Parrots of Telegraph Hill, The (2005)	5, 114
Woman on the Run (1950)	29
X-Men- The Last Stand (2006)	9
Zodiac (2007)	7, 29, 116